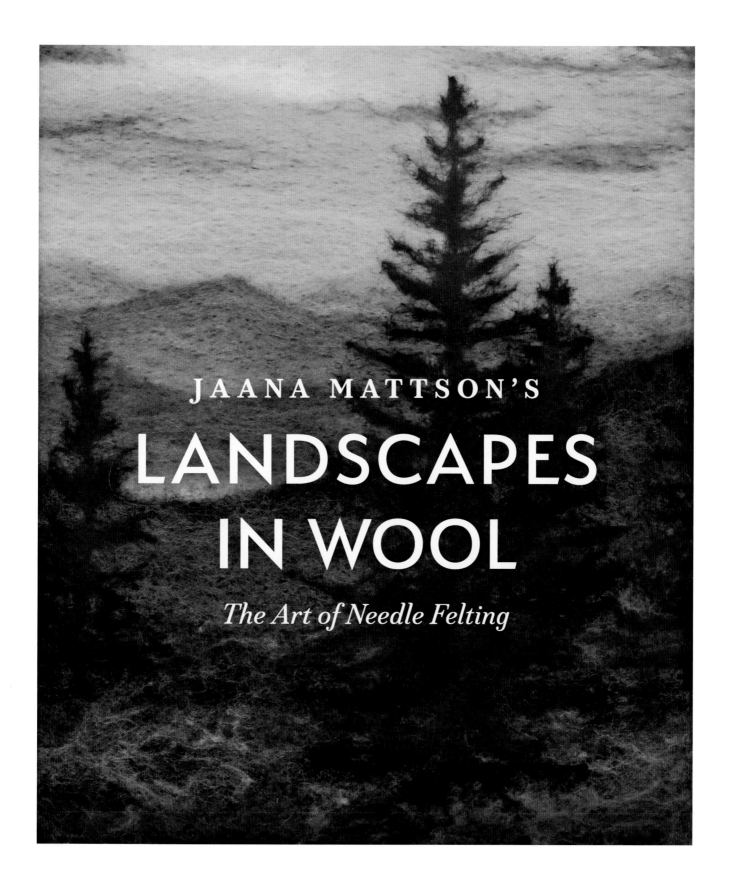

JAANA MATTSON'S
LANDSCAPES IN WOOL

The Art of Needle Felting

SCHIFFER
PUBLISHING

4880 Lower Valley Road · Atglen, PA 19310

Other Schiffer Books on Related Subjects:

Artisan Felting: Wearable Art, Jenny Hill, ISBN 978-0-7643-5852-4

Wool: Unraveling an American Story of Artisans and Innovation, Peggy Hart, ISBN 978-0-7643-5431-1

Natural Dyeing with Plants: Glorious Colors from Roots, Leaves & Flowers, Franziska Ebner & Romana Hasenöhrl, ISBN 978-0-7643-5517-2

Designed by Molly Shields
Type set in Serenity /Cambria

Title page: *Blue Ridge Vista*, 2020, wool, found frame, 13" × 11.5" × 1"

ISBN: 978-0-7643-6126-5
Printed in China

Published by Schiffer Publishing, Ltd.
4880 Lower Valley Road
Atglen, PA 19310
Phone: (610) 593-1777; Fax: (610) 593-2002
E-mail: Info@schifferbooks.com
Web: www.schifferbooks.com

For our complete selection of fine books on this and related subjects, please visit our website at www.schifferbooks.com. You may also write for a free catalog.

Schiffer Publishing's titles are available at special discounts for bulk purchases for sales promotions or premiums. Special editions, including personalized covers, corporate imprints, and excerpts, can be created in large quantities for special needs. For more information, contact the publisher.

We are always looking for people to write books on new and related subjects. If you have an idea for a book, please contact us at proposals@schifferbooks.com.

Dedicated to the generations of
"unknown" women fiber artists, creating
works of beauty and purpose with
artistry, innovation, and love.

INTRODUCTION

6

TUTORIALS

19

COMMON QUESTIONS

84

GALLERY

86

CONCLUSION

124

NEEDLE FELTING GLOSSARY

126

INTRODUCTION

Landscape is full of spiritual spaces. As an artist, I aspire to capture nature as vast, intimate, and transcendent, and it is a challenge to do justice to this feeling, this *sense-memory* of a natural place. I have never been a painter, preferring sculpture and craft forms, but my frustration with representing landscape in media such as quilts, glass, and steel was that my works felt overly stylized: a cartoonish version of my inspiration. It has been intensely satisfying to discover the possibilities of needle felting. After a couple of (sometimes frustrating) early years tinkering with the needle, I began to see that a greater level of detail, layering, and nuance could be reached through needle felting. This became a way to represent both what I see and how I feel about the subtlety and grandeur of the natural world.

Needle felting first captured my curiosity in 2010 through works I noticed at art fairs: three-dimensional animals and finely embellished details on clothing. I realized I was seeing something new to me in the world of art textiles. I had yet to understand the full potential of this dry-felting medium, but I felt the excitement of uncharted territory. I was thrilled to explore and develop in my own space for a while; I drew on an education in the foundations of fine art and fibers to develop a painterly, impressionistic approach of blending and layering techniques, guided by color theory. As my understanding of the materials and tools available grew over the hours and years in the studio, my ability to translate the landscapes in my mind evolved as well. In this book I offer you a gallery of images of my own work in wool and wood, as well as step-by-step tutorials in how I approach needle felted landscapes. The gallery of my own work represents an advanced handling of needle felting developed over the years through experimentation and trial and error in my studio. I hope you will be inspired but not intimidated! The tutorials I offer give the complete beginner a place to start and learn basic techniques I have developed while being introduced to some of the more intermediate concepts of color theory and composition. Regardless of your experience and skill set, the outlined processes can lend a deeper understanding of the work and help you to give it a try.

Processed white batt, processed white merino roving, natural merino roving, and natural batt wool fiber

UNDERSTANDING WOOL

Wool is a lustrous, tactile, transformative material that takes dye beautifully for vivid color projection. It can be used as filaments of color in a painterly way as well as sculpturally for three-dimensional, free-standing forms. Sheep's wool, in my experience, is the most effective fiber for needle felting. The best multipurpose wool for needle felting has some "tooth and kink" to it, so that as you push the fibers through and together with a felting needle, the kinks (or "crimps") will intertwine as the microscopic scales on coarse wool fibers grab onto each other **[see diagram]**. Different types and textures of wool can be needle felted for different effects, and there are many, *many* breeds and blends of wool that have different characteristics. I once thought I could study up and learn everything I needed to know about wool for needle felting, but, truthfully, the more I learn, I realize *the less* I know! The quality and texture of wool is affected by so many variables: climate, landscape, health of the sheep, part of the fleece, breed (with over a thousand different breeds, not to mention crossbreeds), and blends of fiber (see page 9).

For my functional purposes, I ultimately simplified my understanding of wool to two basic *texture* categories for needle felting. Once the fleece has been shorn from the sheep—cleaned of dirt, lanolin, and vegetable matter—the fiber lands somewhere on a spectrum from "roving" to "batt" style wool. Think of roving as tall grass, while batt fiber is a clump of moss (page 10).

Often, all wool for needle felting is generically referred to as "roving," although technically (and for our purposes) roving is strictly a long-staple wool that has been combed or "carded" by machine into linear ropes of loose fiber. These fibers can be laid down in wispy, directional fans and work beautifully for blending multiple layers of color. *Corriedale* is a commonly found breed of roving for needle felting and is a relatively course, all-purpose needle felting wool that spreads evenly across the surface for good blending. A very different example of roving is *merino*, also long stapled, but with silky-smooth fibers that work great for spinning and wet felting—however, for needle felting it can be streaky and difficult to blend.

Batt-style wool is a very kinky matrix of fibers without direction. This type of fiber has exceptional crimp and is therefore very elastic and malleable to shape on the surface of your textile, making it great for trees, clouds, and other discrete forms. I rarely find that the batt wools I use are identified by breed, since they are often labeled simply "core wool" or "fluffy batts." *Suffolk* is one breed that exemplifies short and downy fiber that builds good bulk in the batt style.

As a rule, avoid cutting wool—roving or batt—with scissors. Cut wool is more difficult to manage, since it will result in irregular lengths with short ends. Cutting small amounts can be handy for working details such as branches but should otherwise be avoided. To separate workable quantities of wool roving, place your hands across the grain of fibers 4–8 inches apart and gently pull. If the wool is not separating easily, then slide your hands farther apart. Batt fiber can be pulled away in pinches.

I encourage you to experiment: get to know the feel of different types of roving and batt fibers from different varieties of sheep, or even blends with other animal fibers such as angora, yak, alpaca, or silk. I find that many different fibers, when they are mixed with sheep's wool, can have some interesting results when needle felted.

FIBER TYPES

fine: Wool of consistent, fine fibers throughout the fleece of a 2"–4" staple. Soft next to the skin but not strong. Can be used for needle felting but with challenging characteristic.
examples: Merino, Rambouillet, Cormo, Targee, etc.

medium: Most versatile medium-diameter fiber, with a 3"–6" staple. Felts quickly and easily; flexible and durable due to length, strength, crimp (6–7 per inch for elasticity), luster, and bulk.
examples: Corriedale, Finn, Columbia (western US), Tunis, Montadale, Cheviot, etc.

down: Wool of a short-staple, medium-diameter with a matte finish and a spiral crimp for great resilience and elasticity, used for quilt batts and cushioning. Needle felts easily.
examples: Clun Forest, Dorset Down, Shropshire, Suffolk, Hampshire, Welsh Mt., etc.

long: Larger-diameter, long 5"–12" staple. Strong and hard wearing, with a lustrous, silky feel of inconsistent quality depending on the part of the sheep the fleece is from.
examples: Coopsworth, Romney, Border Leicester, Blue-Faced Leicester, etc.

wool: A matrix of keratin fibers covered with minute scales

Fine Wool
e.g., Merino

Coarse Wool
e.g., Romney

vs. non-wool fibers

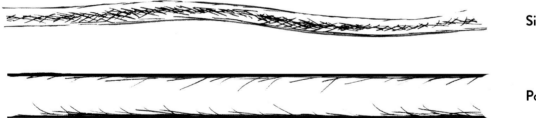

Silk

Polyester

double-coated: Wool of heritage breeds that retains primitive character of long outer coat (up to 18", coarse fiber with no crimp) to repel weather and soft down undercoat (spiral crimp) for warmth. Fibers can be separated for different characteristics.
examples: Karakul, Icelandic, Shetland, Navajo, Scottish Black Face, Churro, etc.

roving-style fiber: Tops or long-staple fibers that have been drawn into continuous thin rope of loose fiber to be used for spinning or felting. Great for blending and linear forms.

batt-style fiber: Sheets or wads of loosely entangled, kinky fibers resembling quilt batting. Sometimes short and downy. Great at building bulk for discreet objects.

FIBER CHARACTERISTICS

Fine

Medium

Long

Downy

Double Coated

Staple: Length of an individual fiber

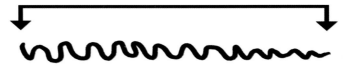

Crimp: Natural kinks or bends in an individual fiber (elasticity)

Roving Style

Batt Style

TOOLS AND MATERIALS

Foam work surface: Needle felted textiles are created on a foam block so that the needle has somewhere to go as it drives the fibers through the surface. The completed textile is then removed from the foam block. Dense, high-grade, open-cell foam is best, since it stays firm as the needle passes through and does not degrade too quickly. Almost any cushion foam can be used, but the softer foams offer less control because they sag under your work and bounce beneath the needle. High-density foam, often sold as *packaging* or *acoustic* foam, allows your needle to penetrate without compressing, and uses the whole movement to work the fiber through the surface. Foam will also break down with use, softening from repeated needle jabs. In most foams, if I am building up very detailed areas with a single needle, I may tear up chunks of the work surface as I pull my completed textile away. See the "Common Questions" section for guidance here, and don't worry too much about chunks of foam stuck in the back of your textile. It is the backside and not as important as the work you've done on your image. I can typically get one to four uses out of a piece of foam before it gets big potholes or becomes too soft. We all have different levels of intensity in our felting, and "emphatic" needle felters will go through foam more quickly.

Base felt: While it is possible to build a textile entirely by needle felting wool fibers, it is simpler and quicker to start an image with a fabric as a "canvas." I find that inexpensive white acrylic or polyester craft felt is the best option for optimum control. When secured with roundhead pins to the foam block, the needle slides through the craft felt easily without resistance. It is archivally stable, and since the base felt will be completely covered in wool fiber, the material content is not important to the final visual effect. If you prefer to be consistent in your fiber type, there are many options out there in 100 percent wool felt or pre-felt (a lofty wool material that has been partially felted into loose fabric sheets). If you do want the base fabric to show as part of your piece, I would recommend trying a natural fiber such as wool or linen. Experiment!

Felting needles: Originating from industrial felt production, a felting needle is a very sharp single tine of highly tempered steel with notches cut into the sides near the tip to snag fibers. After trying all different shapes and gauges of needle (star, spiral, reverse barb, fine, and thick), the only needle I now use is a 38-gauge triangle, the most common size available. In a triangle needle the notches are cut into the three edges along its length, within about ¾" of the tip. To push your needle more than an inch through the surface of your foam block is wasting your effort, since there are no more notches snagging the fiber beyond that point. Larger needles (smaller gauge numbers) can be faster and grab more fiber but lack nuance and leave more-visible needle holes in your textile. Finer needles (higher gauges) can be more precise and leave more-delicate marks but take longer to work the material. I have also seen needles come in different lengths, so be sure your needles match when used together in a multi-needle holder. Felting needles are very brittle and will bend and snap with any sideways pressure. Be prepared to break some needles; certain techniques and basic bad luck can push the limits of your needle, and it happens fairly regularly. Felting needles also come with a small bend at one end to anchor the needles into various hand-held holders. Additional tools and needle holders from three to twenty needles allow for refined techniques and efficient felting, as I will outline in the tutorials. The first couple of years when I began experimenting with needle felting, I used only a single handheld needle, since I didn't know of available tools or what to use them for. Aside from sore hands and extra labor in this labor-intensive process, I was able to create a range of effects and develop different techniques. Adding additional tools to your studio gives you more options for refined and efficient process, but you can work with a single needle (see page 13).

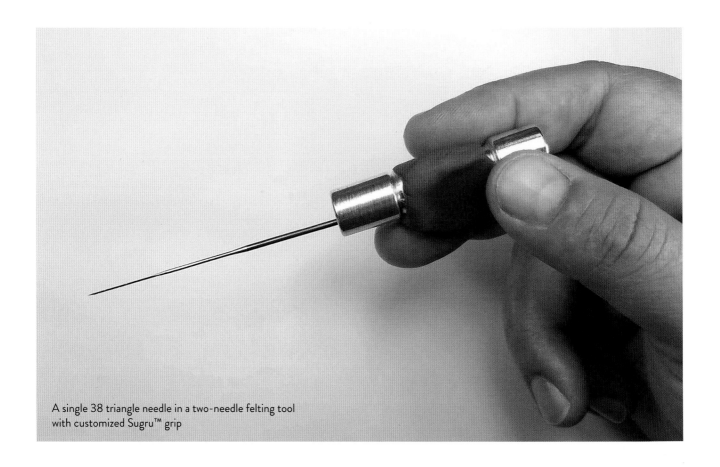

A single 38 triangle needle in a two-needle felting tool with customized Sugru™ grip

ADDITIONAL TOOLS

- **Aluminum multi-needle tools:** Hand-tooled, lightweight aluminum handles of various sizes, from two to twenty felting needles. The handle screws off, making needle changing simple. Finely machined holes hold needles tightly, with 38-gauge triangular-point felting needles included.
- **Six-needle felting tool:** Holds six needles over ¾" area, felts six times faster for large areas and blocking, and also is very helpful for keeping broad wisps and fans of fiber spread out as you felt, for superior blending and tonal progression.
- **Four-needle felting tool:** Holds four needles over ³/₈" area. Good for blending smaller areas, keeping fibers spread out on the surface as you felt in smaller compositions or narrow features (e.g., tree trunks).
- **Two-needle felting tool:** Commonly used with one needle for a nicely weighted single needle holder, keeping your hand out of the sight line of your work, and easier to grip than a needle alone.
- **Embroidery scissors:** Fine scissors with long, slim blades work best to trim small wisps of fiber for detail work or to slip between layers of felted wool to "excavate" underlayers of color.

- **Clear "quilting" rulers:** 6"–12" square to 6" × 24"; to check alignment of horizon as you work, use as a straight-line felting jig and to trim finished work with a rotary cutter.
- **Shears or rotary cutter with mat:** To trim finished textile
- **Sugru:** A moldable rubber material; comes in small packets of different colors, sets overnight, great for forming ergonomic grips on tools
- **PVA:** Polyvinyl acetate. An archival artist's glue. Starts white, dries clear, and is flexible, acid free. Can be used to attach textile to any surface (glass, wood, metal, paper, other fabrics). Available from art supply retailers, often found in bookbinding section. Spread a thin, even coat on nonfelted surface and then press textile into place.
- **Lighting:** A bright full-spectrum lamp gives a vivid, natural daylight view of your work for true color and fine detail. I suggest full-spectrum LED task lighting.
- **Bandages:** It's always good to keep a supply of adhesive bandages on hand, even for the "experienced" felter.

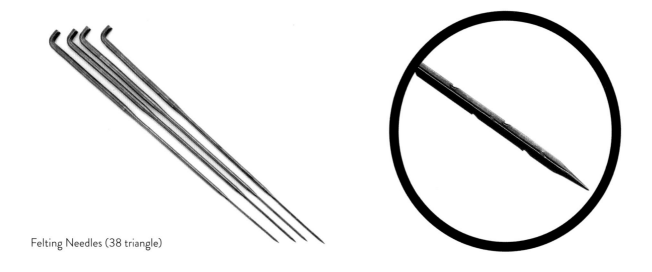

Felting Needles (38 triangle)

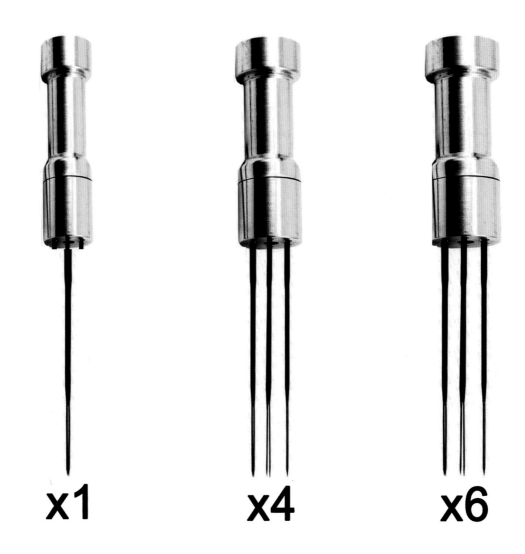

Multi-Needle Holders

x1

x4

x6

COLOR BASICS

Color is created in the eye of the beholder, and as a language it conveys more than an object's literal appearance. We attribute many feelings to color, often considering red to be strong, self-assured, and dominant as a warm color that "pops" forward, while blue can be perceived as calm, patient, and passive, a cool color that "recedes" to the background. Additionally, we often have uniquely personal associations with color; colors can be memory triggers and can inspire subconscious reactions. Color can carry strong feeling to the viewer, whether universal, intentional, or not.

It is the emotional roots of color that inspired the Impressionists to experiment with this perception as a vehicle for meaning. Originating with a group of innovative French painters from the late nineteenth century (for example, Monet, Degas, Renoir, and Gauguin), Impressionism explored different combinations, proportions, and juxtapositions of color for emotional impact. One might think this sounds wildly abstract, but the thoughtful use of color theory can give heightened emotional impact to even the most realistic landscape. Before the existence of CMYK and pixel technologies, the Impressionist painters pushed the idea of "optical mixing," where the eye combines two or more colors that are positioned next to or near each other, such as perceiving intermingled blue and yellow dots as green. The fact that this perception of color is created *within* the eye of the viewer creates a more dynamic impression of what is being seen. This is the idea that consistently motivates me to explore the energy to be found from playing with new ideas of color. I primarily employ the use of complementary colors when I want the richest contrast or most energetic area of focus. If a piece is serene and calm, I will not use the high-contrast techniques of

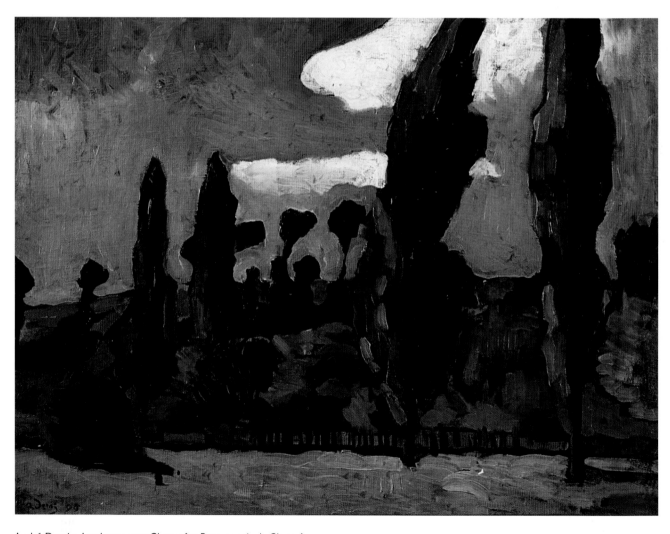

André Derain, *Landscape near Chatou* (or *Paysage près de Chatou*), oil on canvas, 1899 (private collection)

playing with COLOR THEORY

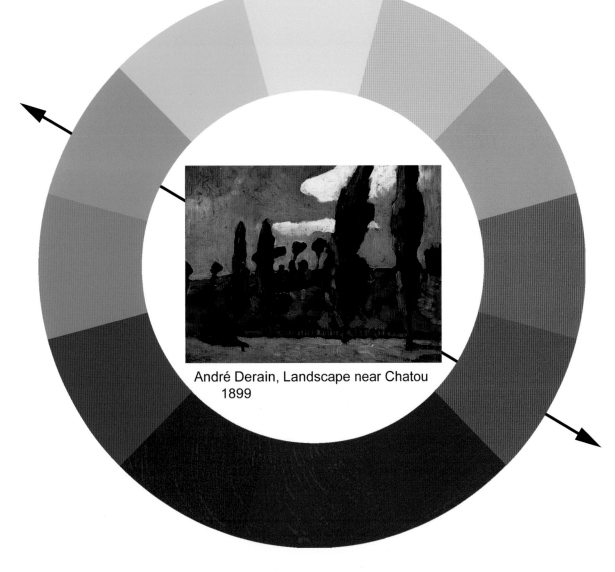

André Derain, Landscape near Chatou
1899

complementary colors—likewise, within an area where I intend to allow the viewer's eye to "rest."

A color wheel, a vocabulary of common color terms, and some simple suggestions within the tutorials for how to approach color all play a part in the step-by-step process to help you use colors effectively. My personal approach is more gut reaction than science, but I do apply some fundamental principles of color theory. In my studio I glance at my color wheel frequently as I work, play with a reaction sparked there, and trust my instincts. My goal when teaching is to offer some introductions to this emotional mystery without overwhelming the beginning student with theory, but as you gain confidence and experience, I encourage you to continually explore innovative use of color in your work.

COLOR THEORY VOCABULARY

primary color: Red, yellow, and blue: basic pure colors that cannot be made by mixing any other colors

hue: Every color is a "hue" (i.e., red, blue, yellow, orange, purple, green . . .)

shade: Hue + black for a lower value (darker)

tint: Hue + white for a higher value (lighter)

tone: Hue + gray for degrees of tint and shade

value: The lightness or darkness of a hue or color

saturation: The intensity or purity of color, affected by the amount of gray added to a hue

warm vs. cool: Warm colors advance (typically hues from red through yellow, browns, and tans), while cool colors recede (from green through violet and most grays). *Relative* color temperature also affects the perception of depth. For example, within dense foliage the warmer greens (with more yellow) feel closer, while cooler greens (with more blue) tend to fall back into shadows and distance.

complementary color: Two colors that are on opposite sides of the color wheel (such as red and green). When placed next to each other, they create the strongest contrast for those two colors, but when mixed will cancel each other out to make gray or black. Also called "opposite colors."

optical mixing: The visual mixing of colors performed by the eye from a distance, a phenomenon that happens in the viewer's perception as a result of two or more colors that are positioned next to or near each other.

underpainting: First layer of color applied to a canvas, which functions as a base for other layers of color

Impressionism: A style of painting representing a visual impression of the moment in the shifting effect of light and color, seeking to capture a feeling or experience rather than to achieve accurate depiction. The movement originated in 1860s France and included such artists as Renoir, Monet, Degas, Pissarro, and Manet.

Fauvism: A post-Impressionist style known for an aggressive use of brilliant and highly saturated colors, flattened composition, and choppy brushwork for an emotive, vivid, and energetic style. The movement originated in 1905 in France and included such artists as Derain and Matisse.

COMPOSITION BASICS

The idea of "composition" is to create interest in your work by guiding the eye through and around your image on a visual journey, making sense of the story you want to tell like an artful connect-the-dots. A strong composition will compel you to keep looking around an image and help your brain make sense of what your eye sees, for a compelling visual experience. I have found wool to be a very forgiving medium to practice these ideas, since you can simply pull away your most recent efforts with no ill effects to try it again, or quickly cover areas with many attempts to get it right without creating a muddy mess. I am often asked if I sketch my composition before I start felting, but the fact is that I simply sketch with the wool as I build my image, adding, moving, and removing until it feels right. As I develop my landscape in layers, blocking in shapes, I spend a fair bit of time squinting and tilting my head before I commit and spend too much time developing nuance and detail. This allows me to evaluate my composition as it develops beneath my hands with my mind's eye, taking in my reference photographs and the elements of my image that have yet to be added. Of course, there are exceptions to every rule, and you can find playful and effective examples that break each of these, but I will outline some common devices as a helpful beginning guide for approaching naturalistic landscape. Study plenty of photographs to help yourself understand these concepts; it helps make sense of the elements we subconsciously take for granted in the way we see landscape.

Avoid symmetry: "Symmetry is boring" is a fundamental that was embedded into my psyche in art

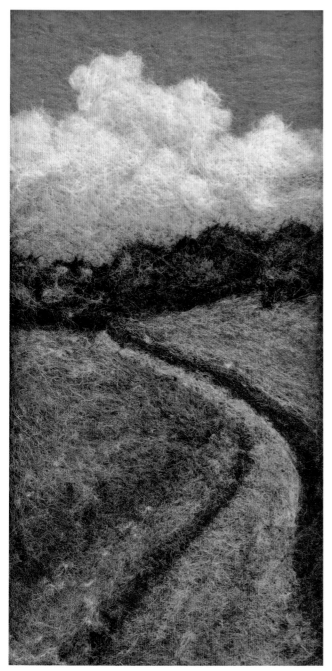

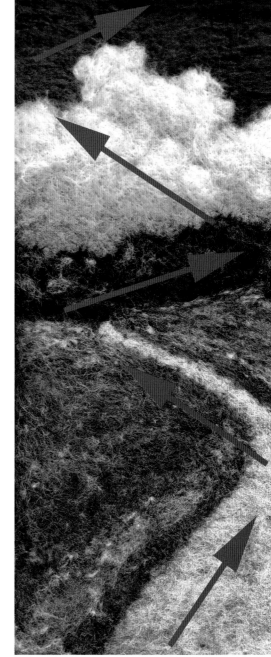

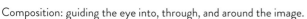

Composition: guiding the eye into, through, and around the image.

foundation classes. An evenly divided canvas is as interesting as a spreadsheet, so don't divide your picture in half by placing your horizon in the middle or a tree at dead center. Avoid evenly divided sections and centering objects and creating mirrored shapes on each side. A row of the same trees is monotonous, and actual clouds always vary with distance and wind into oddly unique shapes and groupings. Remember that a sky full of identical clouds feels like a cartoon, so vary the shape, size, and spacing of repeated elements.

The rule of thirds: A common concept that helps remind you to divide your canvas in a more interesting way. If you have a focal point, set it one-third of the way across your piece, such as a horizon line one-third of the way up or down from the edge.

Avoid repetition: It is a common tendency to create repeated elements in a pattern, such as clouds evenly sized and spaced like polka dots or identical trees that look like soldiers in formation on the horizon.

Be aware of this tendency and work to break up the patterns, remove an element, or link them together to disrupt the repetition.

Focal points: Arrange your strong elements (cloud, tree, bush, house) to create a visual journey around your image, and be selective. Too much activity and too many elements crowded into your composition can create confusion and flatten the effect of your landscape.

Visual resting place: Create spaces for the eye to rest between strong focal elements. I often use the simplicity of blue sky or a clearing in the treeline as a break from the focal points of my work. If the eye doesn't have a resting place or breathing room, it tends to get overstimulated and lose its path through the piece.

Negative space: A very important element of composition that is often overlooked is the shapes created between objects, such as the blue sky between cloud forms or tree branches. Be conscious that these parts of your landscape are as relevant to your work as the cloud and tree itself, and evaluate them as well for problems with symmetry, repetition, and visual interest.

Objects at the edge: It is also a common tendency to want to complete objects (clouds, trees) before running off the edge of your composition, rather than letting them get cut off. Push yourself to hint at larger elements that continue beyond the edges of your image for a better interpretation of realism, such as an open window frame that exposes only part of a view.

Depth: Realistic landscape requires the illusion of depth and distance. Establishing the distinction between far distance, middle ground, and foreground will make sense of the physical world you seek to represent. The perspective tricks outlined here can help increase a sense of depth in your work.

- **Overlap:** Closer objects cross in front of those behind, such as tree branch over a mountain or grasses in front of a tree trunk. A simple tool to put a group of elements in perspective for a better grasp of distance.

- **Texture:** Closer elements in the foreground should emphasize visual texture with distinct, variegated, and more diverse color and detail, while further objects are simplified and more generalized in shape and color.

- **Color perspective:** Warm tones feel closer and jump to the foreground (such as yellow/green foliage), while cooler tones recede (hazy blue mountains or a dark-green treeline).

- **Atmospheric perspective:** Colors appear lighter with increased distance, since light scattered by the atmosphere creates a diffused light. Mountains fade in saturation and tone as they become farther away, appearing fainter, cooler, and more blue. Also called "bluing out."

- **Linear perspective/scale:** Evenly spaced objects become closer and smaller as they recede in the distance, until they overlap or reach a vanishing point. Common with cumulous cloudscapes, fence posts, or trees along a road.

Finally, critique your own work. Taking a step back, leaving the room for a while, or gazing at your own work in progress for stretches of time are critical to assess the success of a composition as it develops. Take a break, come back for a fresh look, be conscious of what you feel is working or not working, and then use the Composition Basics section above as a checklist to make sense of these reactions and decide your next steps with a piece.

TUTORIALS

Ready to give it a try? This book includes five step-by-step projects designed to introduce needle felted landscapes in a hands-on way. I suggest you begin with the first project, "Vibrant Fields," which is written to guide the beginner through new tools, materials, techniques, and vocabulary; explaining the "why" as well as the "how" of each step. The projects that follow build on these fundamentals with even more ideas, such as stormy skies, moonlit forests, "growing" a tree, and water effects. Your hands and mind start to understand more with each project, so go easy on yourself and have some fun with your first efforts. After my own first primitive attempts years ago, I was very frustrated. I didn't know what was possible, and I just thought the materials were too hard to control. Eventually curiosity got the better of me and I was drawn in slowly, realizing the benefits of persistence and experimentation. To this day, with each piece that I complete, I strive to push myself, evolve, and improve. Try out these projects, keep playing, and I hope your journey can bring you to new creative frontiers too!

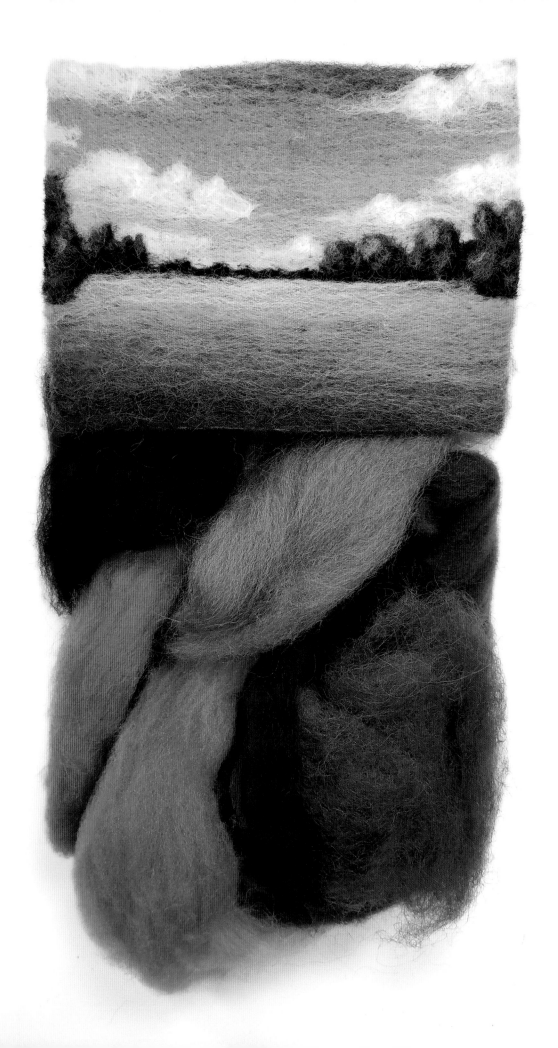

Project objective

This first project introduces basic techniques that lay the foundation for subsequent tutorials in this book, so get to know these steps before you move on to the Thunderhead, Moon Shadows, Birch Lake, and Lone Oak projects.

VIBRANT FIELDS

Vibrant Fields is a project I teach in my introductory workshops. It's a great way to approach some basics such as blending, fine lines, nesting, and simple color theory, among other things that we rely on in later projects. The project ends with a section on finishing, which applies to any of the following tutorials in this book.

→ If you want to try this project with only a single needle, the blending techniques described with the four- and six-needle holders can be approximated, but be sure to jump the needle around the loose fiber before anchoring fully, to prevent the wool from clumping too densely.

SUGGESTED MATERIALS

- 14 roving colors, as outlined in the wool chart for this project
- Foam work surface (8" × 10")
- Craft felt (5" × 7")
- 4 head pins
- Single felting needle (with or without handle)
- 6- or 4-needle holder, or both (as a blending tool)

Suggested wool chart

Study your reference photo and assemble roving for the project.

Color Key:

B1: Navy
B3: Lake
B7: Brite Sky
B8: Light Blue
G2: Deep Forest
G4: Grass Green (B)
G8: Brite Moss
N1: Black
N8: Natural White
W3: Wine
W4: Red Fire Engine
W6: Blaze Orange
W7: Gold
W9: Lemon Yellow

Anchor felt to work surface

Pin the base felt to the foam block at each corner, using head pins, holding each corner under slight tension as you pin for a taut work surface.

Divide composition for a visual guide

You can guide your composition with marks along the edge of your foam block. Mark your horizon line first on both sides, one-third up from the bottom of the felt. Above the horizon line is the sky section. Divide this area into three even bands to guide the progression of three values of sky blue.

→ You can draw on the base felt, but lines drawn on the surface will soon disappear under layers of wool.

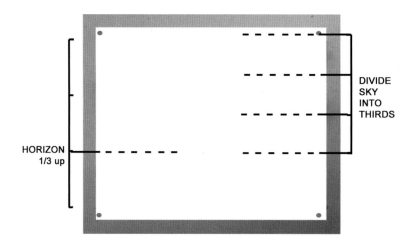

Pull a fan of roving for blended layering

When filling large areas or blending values, pull a light, wide "fan" of roving rather than a thick "pinch."

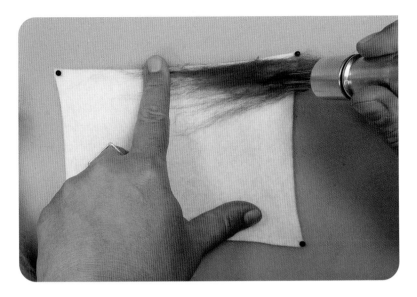

Begin the darkest blue in the top section of sky

Lay one wisp at a time in a loose fan of wool over the surface horizontally, and anchor with a six-needle tool, using a shallow poke (¼" or so). Don't hold the wool down tightly with your other hand; the fiber needs to be loose as you felt. Begin with the top third of the sky in your darkest value, felting and adding wisp after wisp to fill the area completely so that you see no white through the wool, before moving on to the next-lighter tone of blue.

→ Always begin with the most distant part of the landscape (the sky) and build forward, layer by layer. Within each layer, begin with the darkest tint, layering each progressively lighter value over it for optimal blending.

→ If you do not have a six-needle tool, you can accomplish most of these effects with a single needle, but you should skip the needle around the entire fan of wool as you go, so the fiber does not bunch up in one spot.

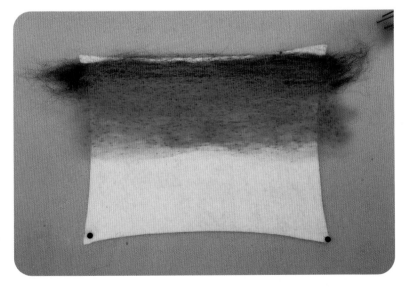

Blend the second value of sky blue

Once the top third is solid, fill the center third of the sky with the next-lighter blue. Blend subtle wisps of the lighter blue upward over the deeper blue to create a gentle transition until just a few fibers of the middle blue reach the top, for a seamless ombré effect.

Fill lightest sky blue down across the horizon line

Complete the sky, filling the bottom section with the lightest blue until solid, filling ¼" lower than your horizon line, then blending subtle wisps up and over only the center blue tone.

→ When layering values from dark to light for an ombré effect, blend each lighter tint through the previous value only. If you take the lighter wool too far over the darker values, it appears streaky.

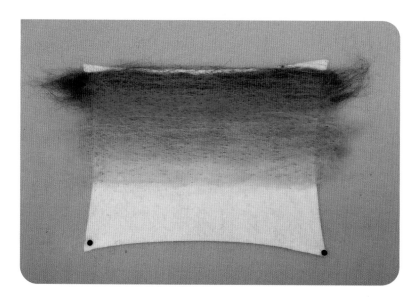

Add horizon line for reference in a complementary color

Create a felted line across the horizon, using a pinch of deep-red roving. Anchoring the wool off the edge of your base felt, carefully walk a single needle along a thin line (⅛" or so wide) along the horizon from one end of each pinch of wool to the other.

→ Overlap sections of landscape by at least ¼" so that when they shrink as you felt they won't pull back to expose the base felt.

→ Using red on the horizon line where there will be green trees is a complementary color choice to create a dynamic element in the landscape. Using complementary colors (those directly across the color wheel) when layering builds visual energy. You can also leave some areas of your landscape simpler without a high-contrast underpainting (such as the sky) for calmer areas of visual rest.

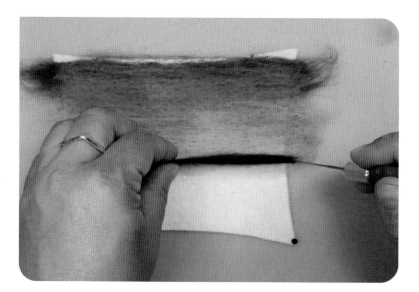

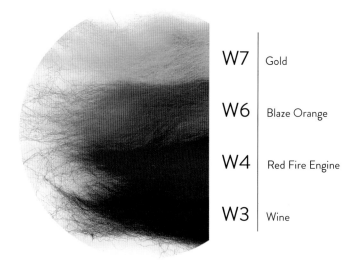

W7	Gold
W6	Blaze Orange
W4	Red Fire Engine
W3	Wine

Assemble complementary colors for "underpainting" of field

Since our goal is a field of deep to bright green, with dark values at the bottom to lightest at the horizon, look at your color wheel to determine the range of complementary hues (across the color wheel) for an "underpainting" to create dynamic visual energy in the finished work.

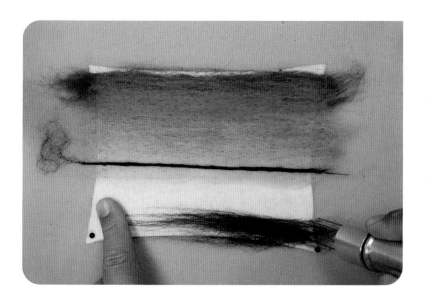

Begin undertone layers of the field

Starting with the darkest value at the bottom of the field, start layering using a six-needle tool. Move on to the next-brighter tone, working through red to orange and finally gold up onto the horizon line. You can be a bit sloppy with the layers here, with gaps and overlaps in color to give the earth some texture.

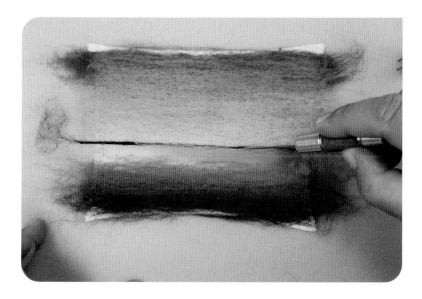

Finish undertone layers up to the horizon

After loosely blending the range of undertones with a six-needle tool, use a single needle to anchor the lightest field tone (gold) at the horizon line, being careful to keep any wisps below that line so they will not stray into the blue sky.

Clouds: Atmospheric haze at the horizon

Pull a fan of white/natural roving and anchor lightly with a multi-needle tool horizontally across the sky, just above the horizon line, to create a distant atmospheric haze.

→ Most "white" roving is actually the natural, undyed wool of "white" sheep. Natural wool comes in varying shades of cream, but if it is the lightest value in your work, it will "read" as white. You can find bleached or chemically lightened wools, but this is rarely necessary to achieve a white effect. Do be aware of these variations when using more than one type of natural wool in a piece (good full-spectrum lighting helps).

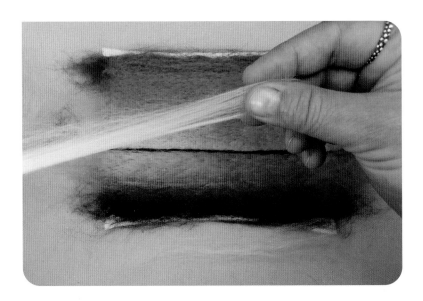

Clouds: Batt- vs. roving-style wool

Batt-style wool, as opposed to linear roving (see Understanding Wool), is much kinkier and will easily felt into fluffy-looking clouds. Roving must be "nested" to achieve this same elasticity, allowing you to shape the clouds effectively. To nest roving, begin with a small wisp and separate the fibers gently.

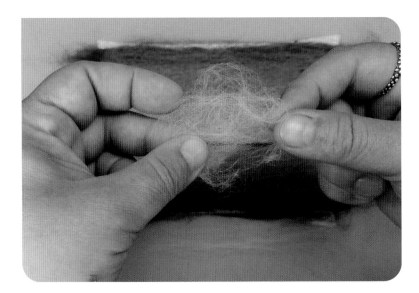

Clouds: Nesting technique continued

Roll the small wisp of fibers between three fingers to loosely concentrate the wad of wool.

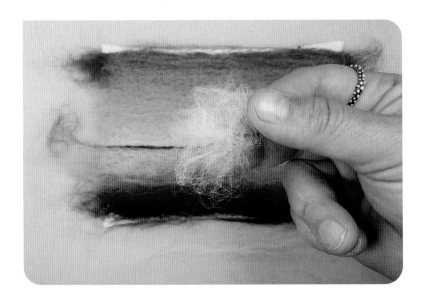

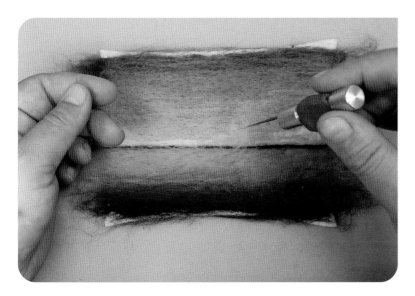

Clouds: Anchor the nested roving

Place the wad of wool on the felted surface and poke in the center a few times with a single needle to anchor the fiber, then circle your needle around the wool to gather the fiber before poking down to anchor the wad, and begin to shape the cloud. The more you circle the wool, the tighter your wool becomes and the less elasticity it retains when felted, so stay kind of loose.

→ No single cloud (or most any shape) is made from a single wisp or wad of wool. Start your cloud by felting one wisp of wool, and add more as needed. This gives you much more control to grow the shape without being "stuck" with a tightly felted single wad of fibers that won't offer the flexibility to manipulate your shape.

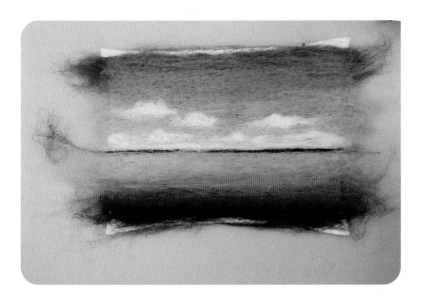

Clouds: Start small in the distance at the horizon

Careful study of a cloud-filled sky will show many small and narrow clouds hugging the horizon, often overlapping in a row.

Clouds: Grow larger and farther apart as they rise in the sky

Be careful not to fill your entire sky with evenly spaced clouds of similar size and shape. Make a conscious effort to create variety in shape and size, growing larger and farther apart as they move upward from the horizon.

→ There is no better reference for clouds than photographs. The shapes in nature are always stranger than our mind's eye wants to believe, and I highly recommend having printed photos on hand for reference if realism is your goal.

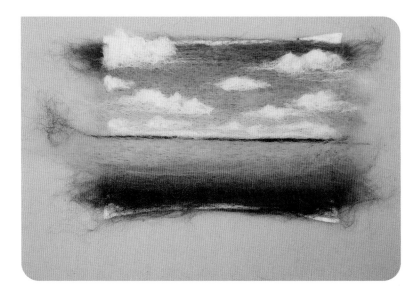

Clouds: Editing

Don't be afraid to pull entire clouds out of your textile if they feel too crowded.

→ Before you move on to the next section of landscape, assess the balance and success of the composition of this section (clouds, in this case). This is your last good chance to easily modify the area before it ends up behind another element, such as trees. Make it interesting, be sure your clouds flow over the edges of your textile, and add or remove as necessary to avoid the common mistakes of symmetry, pattern, overcrowding, etc.

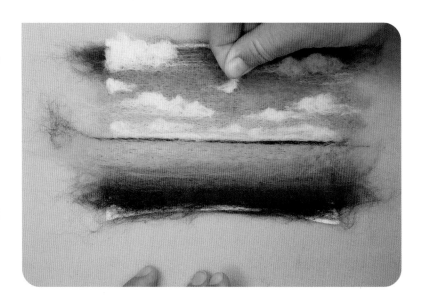

Treeline: Create silhouette with nested wool

Nest wisps of black roving and begin to build your treeline on and above the horizon line.

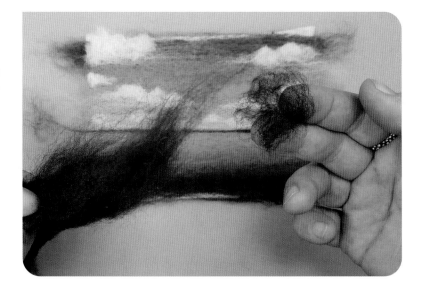

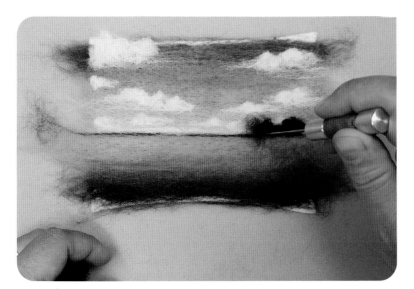

Add nested wads to continue treeline

Add nested wads of roving to create groupings of treetops in silhouette. Alternate shapes and spacing for interest and character, letting the treeline drop to a thin line in the middle to create a sense of distance.

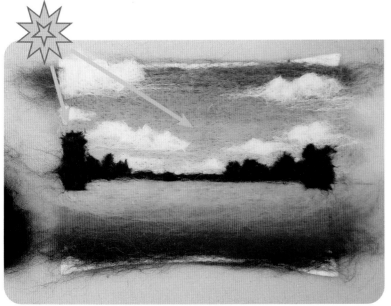

Which way does the sun shine?

Define the direction of the light source.

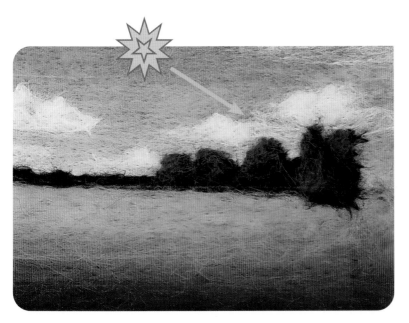

Start with medium-green highlight

On the edge of each shape, where the sun hits the edge of a tree within the silhouette, add a bit of grass-green wool. Cover the black edge with green on the highlight side and let the wool taper out to black on the far shadow side of each shape.

Add brightest-green highlight

Roll a tiny wisp of bright moss green and add a small highlight to the center of each grass-green shape.

Add a splash of navy to offset symmetry

Add a fan of navy roving to one bottom corner of your field to add a bit of depth and shadow to the roll of the land.

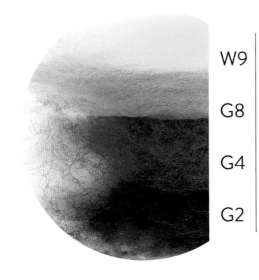

W9	Lemon Yellow	
G8	Brite Moss	
G4	Green Grass (B)	
G2	Deep Forest (B)	

Arrange your field greens, four values from deepest to brightest

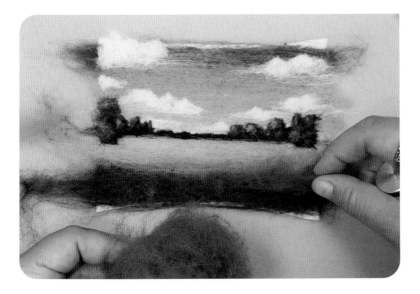

Anchor the deepest green across bottom quarter of the field

Using very loose and open fiber, anchor one wisp at a time, making sure to leave plenty of the undertones showing through the fibers. You will be adding more layers on top of this and can always add more, but it's hard to remove these underlayers if you overdo it.

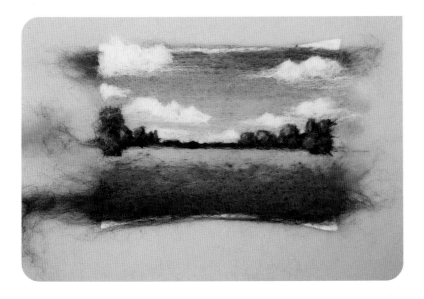

Layer loose wisps of grass-green wool across the field

Overlapping the deepest green slightly, continue with loose and open wisps of grass-green wool up to about the middle of your field.

Add the bright moss roving horizontally up to the horizon line

Use less green wool than you think you want, since it will accumulate with layers to come. You want to keep plenty of the "underpainting" exposed for vibrant, dynamic effects.

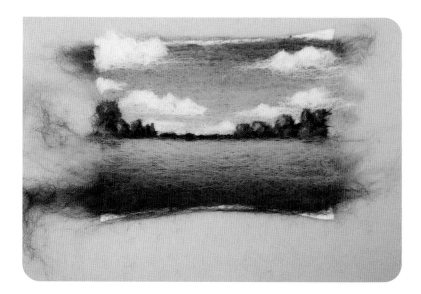

Complete the highlights in the field

With long fans of lemon-yellow roving, add the final field highlights up to the horizon line.

Anchor a clean line at the horizon with a single needle

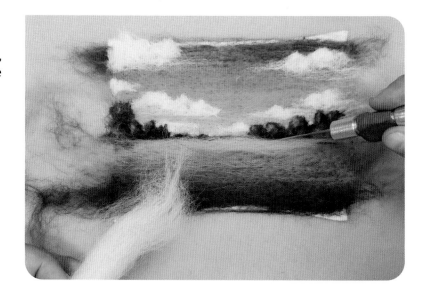

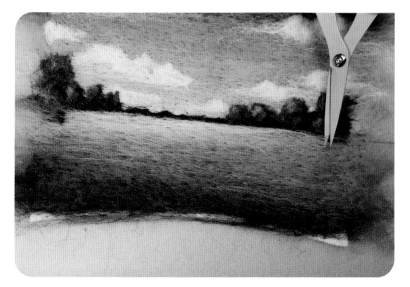

How to handle the base of tall trees

If your taller trees also crossed below the horizon line, let the greens float right over them as you lay in the field. When the field values are complete, snip away or pull back the greens to expose the base of the tree, anchoring with a single needle. This creates an even horizontal flow to the field tones and highlights, rather than an outlined halo effect.

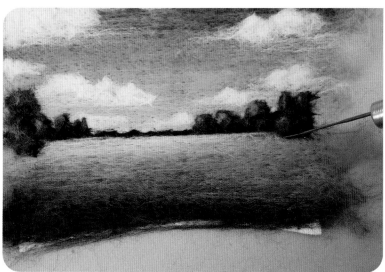

FINISHING

Felt the entire textile thoroughly before removing

When you pull your textile from the foam block, the fibers will distort and shift, so be sure the whole piece has been well anchored (you should see no loose wisps floating above the surface when you look at it from the side).

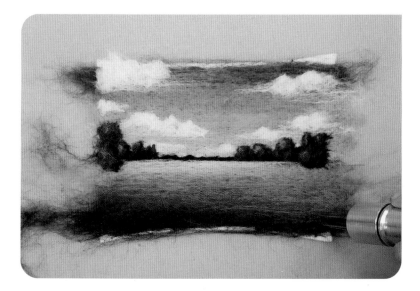

Pull slowly from the corners to remove the textile

Press down on the foam with one hand while pulling the textile slowly but firmly, moving your grip as you pull. If you run into an area that begins to pull up the foam, move to another part of the textile that lifts more easily.

→ If the foam begins to pull up with the fibers, it's best to stop and pull from another side until you isolate the area that is embedded. Don't worry about stretching and distorting your image; you will block the piece after it is free from the foam to realign and anchor the fibers.

→ Often, beginners will felt with great enthusiasm! Consistently deep use of the needle (over ½") can really embed the fibers into the foam block, especially with any detail work using a single needle. No great harm done if you don't mind picking out foam and reblocking the textile, but after several projects you may realize a lighter touch on the work in progress makes for easier finishing of the completed textile.

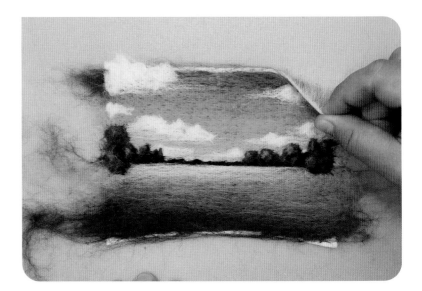

Pull the last embedded area of your textile from the foam

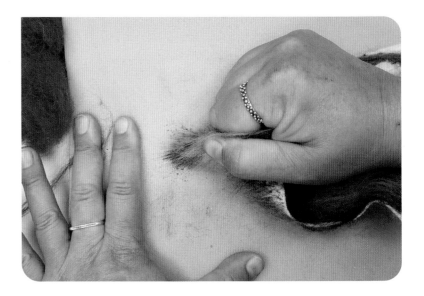

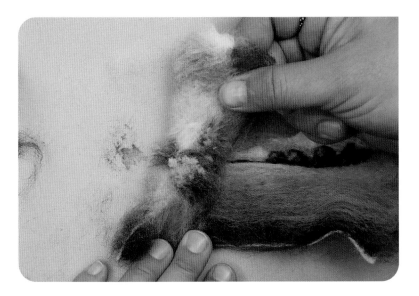

Foam often gets stuck in the back of the textile

Usually, areas that have been worked intensively with a single needle are likely to get stuck and pull up foam.

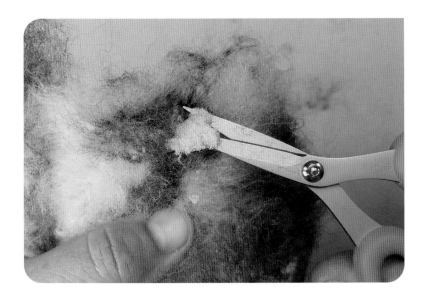

Trim the foam from the backside

You can slide a pair of open scissors under the chunks and pull upward to lift or break up the foam, or you can simply trim the embedded foam chunk to within ¼".

→ Do not trim any closer than ¼" from the craft felt base, or you will be cutting the fibers free from your felted textile. It will not hurt your finished piece to have bits of foam stuck in the back; just trim until the bulk is minimized.

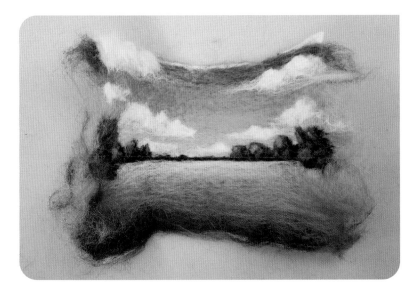

Correct the distortion of the textile

Realign the composition

Begin to straighten the textile after removing by stretching the areas that have been distorted first.

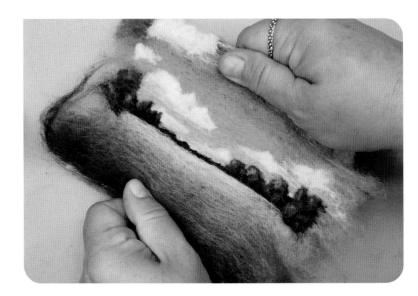

Block the textile

Flatten the textile back down to the foam block, and first correct any straight lines that were distorted with a single needle. To flatten completely, go over the entire surface again with a six-needle tool.

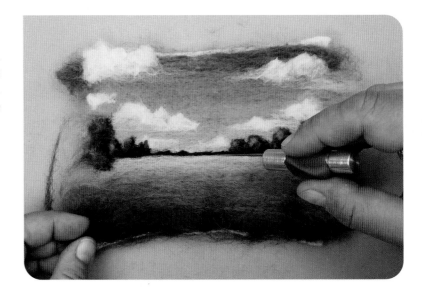

Trim the textile

For a clean-looking composition, first cut away the fiber fringe and bare white felt at the edges.

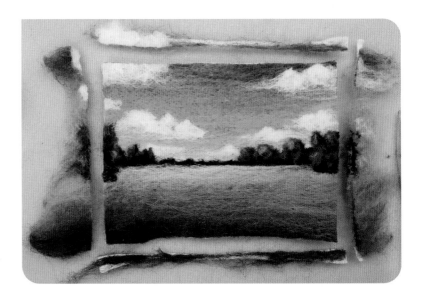

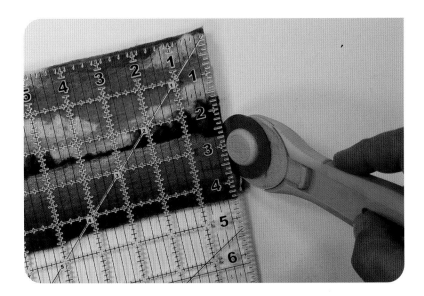

Crop the final piece

A careful final trim can be done easily with a rotary cutter and clear quilting ruler to ensure that the horizon is level. Don't be afraid to cut away as much as necessary for a satisfactory composition.

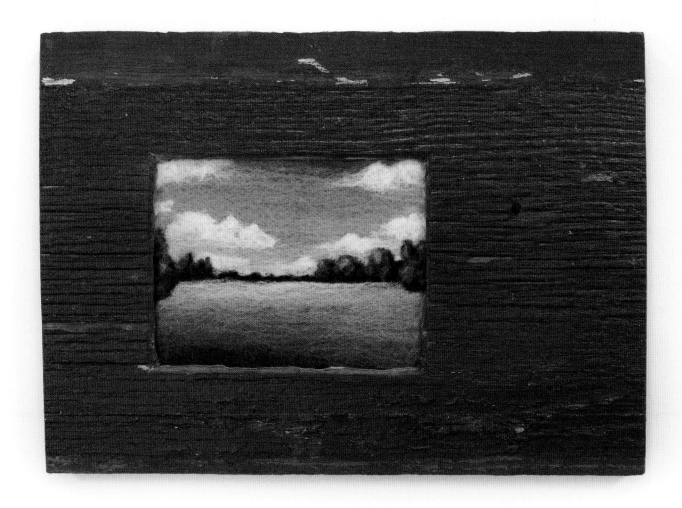

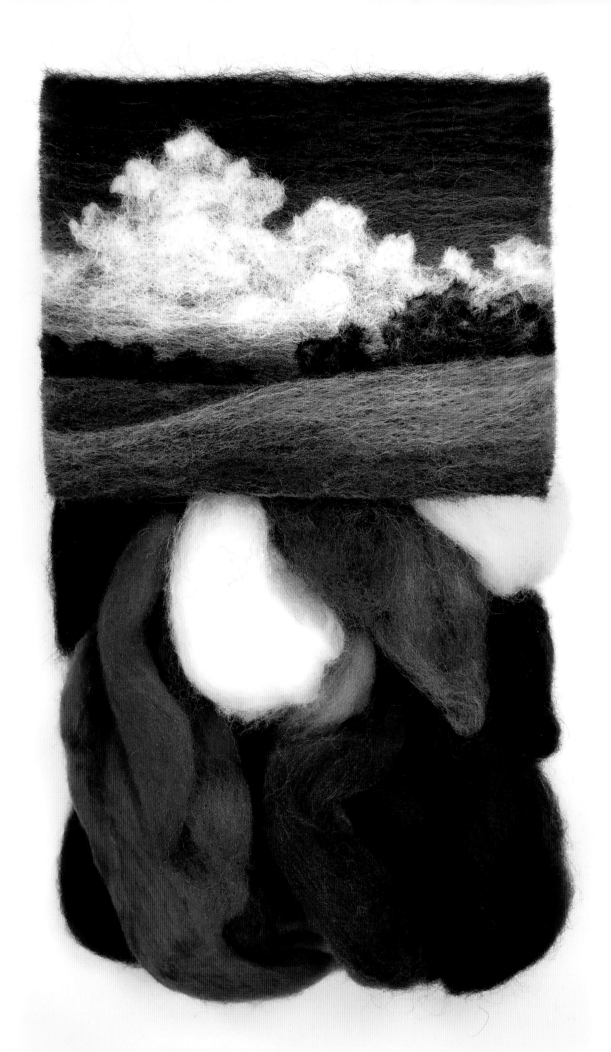

THUNDERHEAD

I love the mood of an incoming storm across the landscape, and there is nothing like a thunderhead to evoke this feeling of impending drama. The Thunderhead project further heightens this effect with a bright swath of sun across the field in the foreground for contrast. This tutorial builds on the skills learned in Vibrant Fields and shows you how to handle the wool for different cloud effects and how to build the landscape from the background forward in overlapping layers to increase the sense of distance.

SUGGESTED MATERIALS

- 12 roving colors, as outlined in the wool chart for this project
- Foam work surface (8" × 10")
- Craft felt (4" × 6")
- 4 head pins
- Single felting needle (with or without handle)
- 6- or 4-needle holder, or both (as a blending tool)

Suggested wool chart

Study your reference photo and assemble roving for the project

Color Key:

B1: Navy
N4: Blue Gray
N5: Med Gray
N1: Black
N8: Natural White
G2: Deep Forest (B)
G3: Vibrant Leaf
G7: Silver Olive
G8: Brite Moss
W1: Chocolate
G10: Toffee
W7: Gold

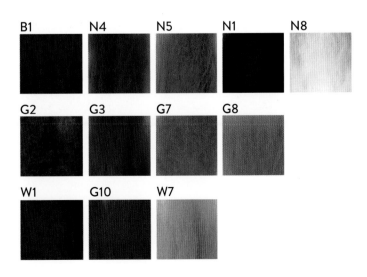

Build your sky in the top two-thirds of the composition from navy to medium gray

Divide your sky into three value sections, starting with navy in the top third, blending with blue gray across the middle, and then medium gray to the horizon, for a subtle stormy transition.

Add light-gray clouds over horizon, covering ground with dark-brown solid

Add a band of white/natural roving lightly across the sky above the horizon line to create a distant atmospheric haze. Fill the foreground field, including a hill up toward the right with solid chocolate brown.

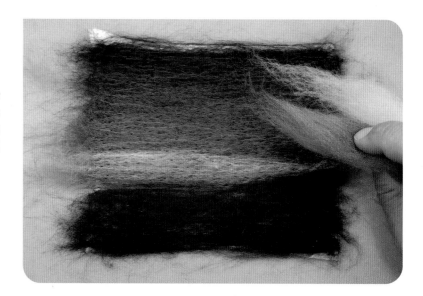

Begin to outline the thunderhead cloud

Nesting wisps of natural roving and anchoring tightly at the edges with a single needle, begin building the large overall shape of the cloud formation.

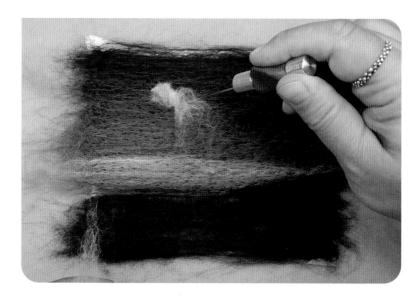

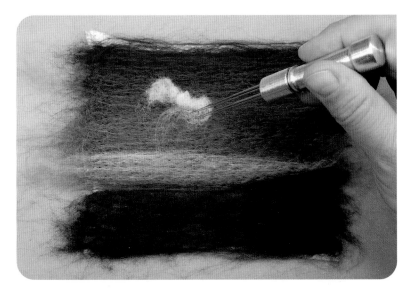

Define a crisp edge to the cloud form with a single needle

Alternate single needle to define edge with a four-needle tool to fill the thunderhead with looser open wisps toward the center.

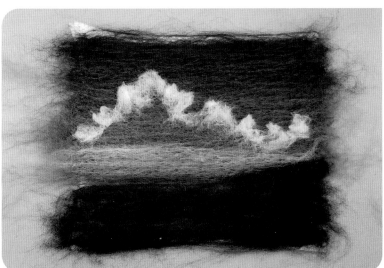

Create "shading" within the billows of the thunderhead

Allow the gray beneath to show through thin areas of white for the illusion of shading.

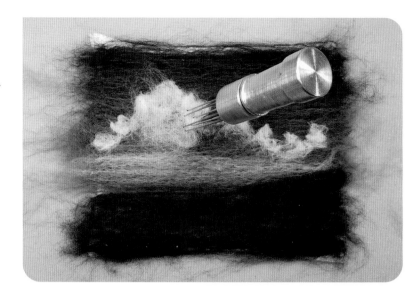

Add highlight and detail within the cloud form

To boost the contrast (and drama) of the clouds, add extra density of white wool in bright areas and be sure to leave areas of gray visible in deeper shadows.

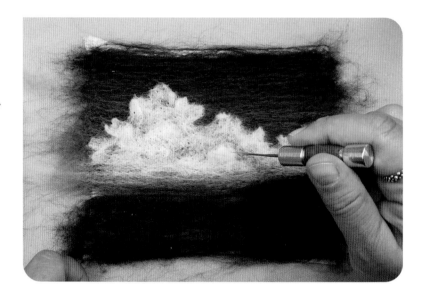

Anchor nested black roving with a single needle to create a solid treeline silhouette straight across the left-hand horizon

You will create a distant field with a hill cutting across in the foreground, so begin with simple trees in the distant part of the landscape (always work with the distance section first).

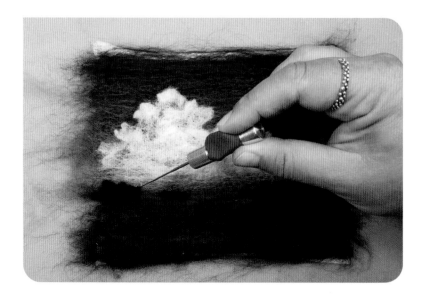

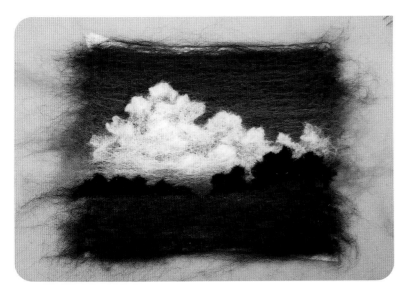

Complete the treeline along the rising hilltop

Things appear larger in the foreground, smaller in the distance, so create taller trees in the closer treeline, alternating shapes and spacing for interest and character in the silhouette.

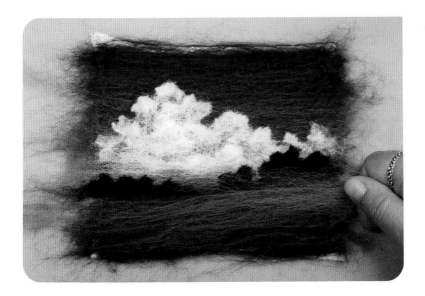

Highlight field with brown undertones

Using light fans of toffee-brown roving, anchor with a six-needle tool while leaving more chocolate brown showing through at the bottom for depth.

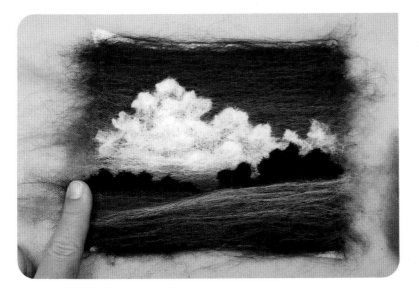

Highlight with gold on hill in the foreground

To give a sense of the sun hitting the field in the foreground under an otherwise stormy sky, you will leave the distance field more muted and add the brighter gold highlights only to the line of the hilltop as it cuts across the field.

Give all trees dimension with subtle highlights

Add a bit of deep forest green and then olive roving in the treetops

Highlight only the nearer trees on the hilltop with brighter greens

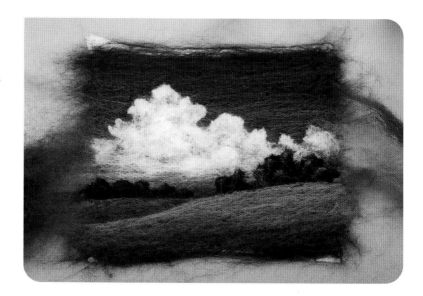

Add overlay of green roving to field

With loose and open fans of fiber, add leaf green to the fields, making sure to leave plenty of the undertones showing through the fibers, finishing with wisps of a bright moss highlight along the hilltop.

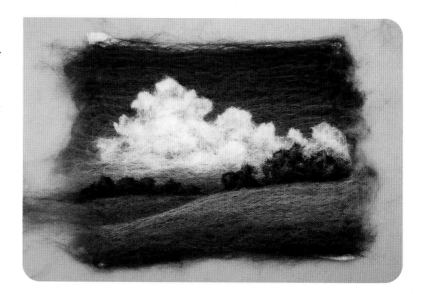

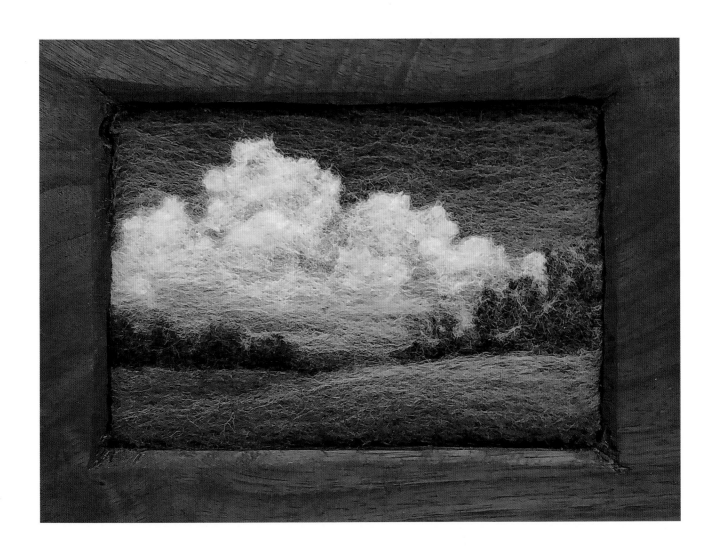

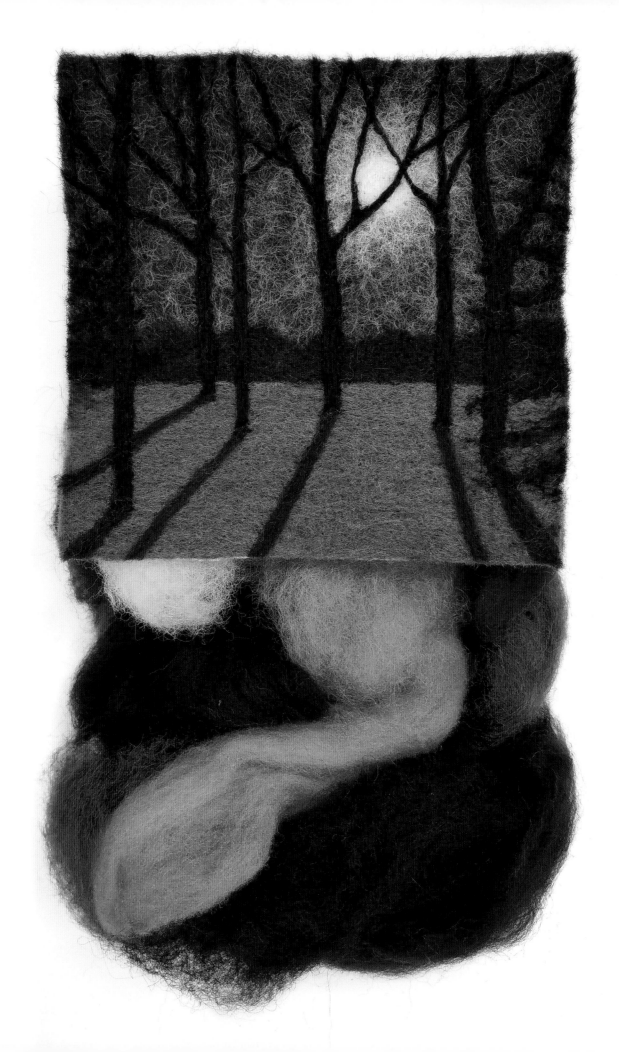

MOON SHADOW

This evocative scene of Moon Shadows always makes me think of my Finnish relatives who insist that those long, dark winter days and nights are illuminated by the bright moonlight on the snow. Here we create a glowing halo around the moon, strong enough to cast shadows through the forest, with a surprising underlayer of color on the ground for depth. Merino wool comes in very handy for building skeletal tree branches, since the fiber is long, silky, and delicate.

SUGGESTED MATERIALS

- 8 roving colors, as outlined in the wool chart for this project
- Foam work surface (8" × 8")
- Craft felt (6" × 6")
- 4 head pins
- Single felting needle (with or without handle)
- 6- or 4-needle holder, or both (as a blending tool)

Suggested wool chart

Study your reference photo and assemble roving for the project.

Color Key:

B1: Navy
B2: Navy (B)
B4: Deep Sky
B6: Brite Teal Sky
N1: Black
N2: Black (B)
N7: Winter White (B)
P1: Ultra Violet

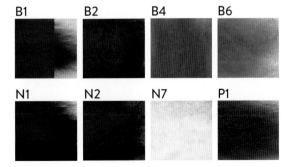

Note the reference marks on the inspiration photo

Adding measured markings (a grid of thirds, fourths, etc.) both to your reference photo and work surface is a good way to guide your composition as you transpose from your inspiration image.

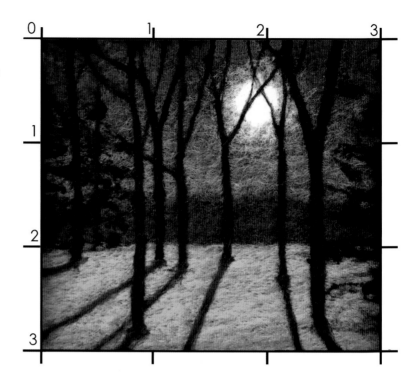

Add guide marks to your foam block

Mark your foam block off the edge of your craft felt base with Sharpie or head pins by dividing into even thirds on all sides.

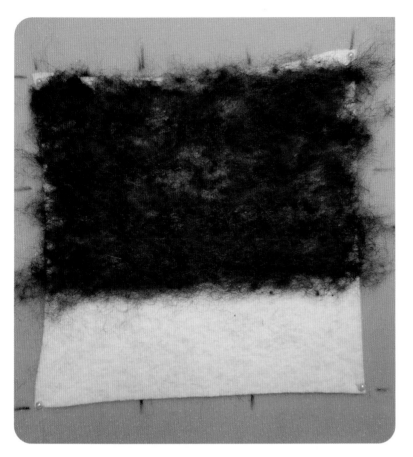

Fill sky (upper two-thirds of composition) with navy wool

Take a small wisp of navy wool and anchor with a six-needle tool. Continue adding and felting lightly (¼" deep) until you cover the sky area of your piece in navy.

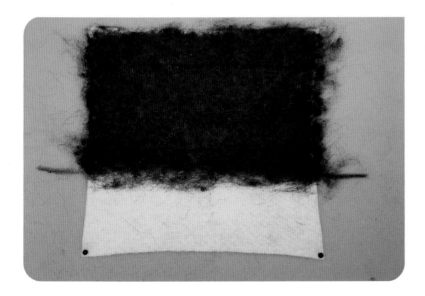

Continue until you see no white base felt showing through

When felting large, solid areas, apply small wisps of wool, anchoring one after another along the same direction and going back over the surface until all white disappears. This will create a smoother textile that blends well with the next layers.

Mark the location of the moon

Notice where your moon will be, using your guide marks as reference, and felt a smaller circle of white fiber here to mark the location (you'll fill in the whole moon later).

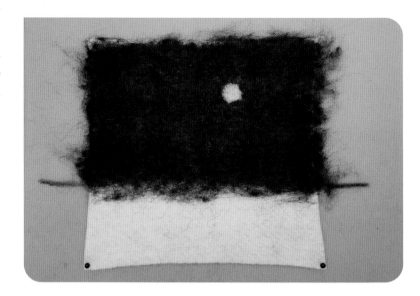

Create a hazy glow in the night sky

Using a teal wool in a kinky batt-type fiber if you have it (or nesting a roving-type fiber), lay down very small and open wisps, anchoring with a six-needle tool to keep the fiber dispersed. Add increasing layers of teal fiber to create a stronger glow around the moon and horizon.

→ When felting fiber for a hazy overlay effect, open up each delicate whisp of wool to remove clumps and pat it into place before felting. Do not hold or touch the wool as you felt it. Holding the fiber under any tension will create tightness and appear like streaks when you want a gentle haze effect.

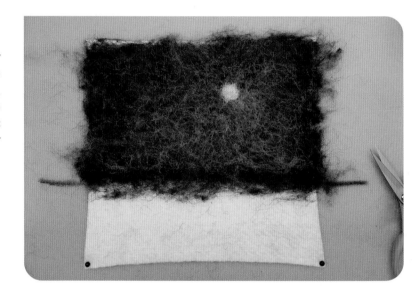

Detail of teal fiber haze over navy

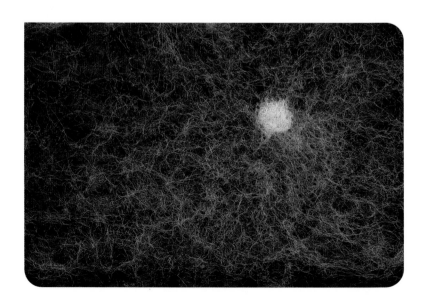

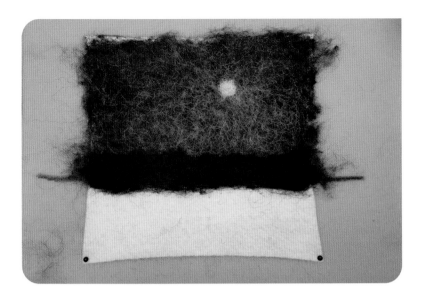

Block in solid dark-navy treeline

Build your solid treeline starting ¼" below the horizon (for section overlap), then up into the sky until it is backlit by the teal haze. Remember to reference your guide marks for scale.

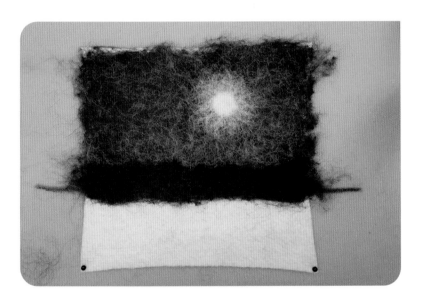

Create a moon with hazy, halo glow

Using a white batt-type fiber if you have it (or nesting a roving-type fiber), fill in a solid circular moon, then create a tight glow around the moon, concentrated toward the center and tapering out about an inch from the edge of the moon.

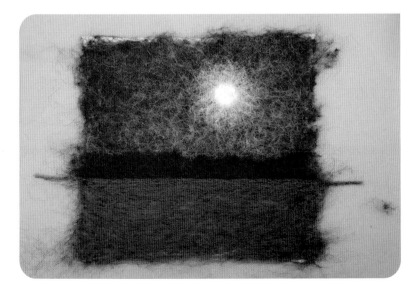

Fill the ground area with a vibrant purple underlayer

This dynamic undertone will add energy to the blue moonlit ground. Fill the ground area with vibrant purple to the horizon line, overlapping your purple field section by ¼" into the tree section.

Add a light, even layer of deep sky-blue roving over the purple

Use a light application and a multi-needle tool for even distribution. Apply slowly and evenly and be careful not to completely obscure the purple. The subtle blending of blue and purple layers will create a luminous effect.

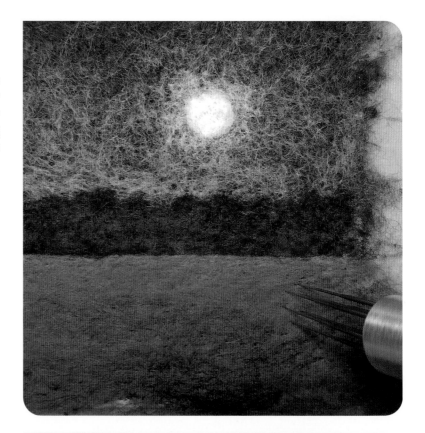

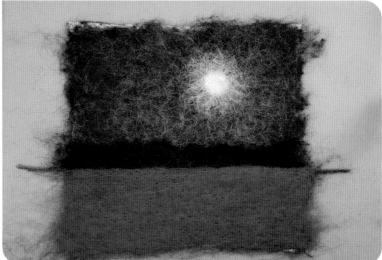

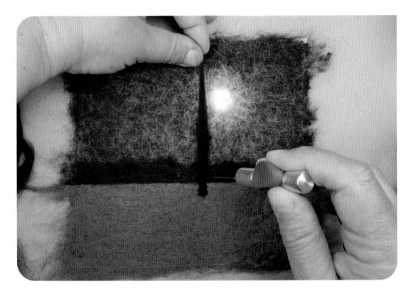

Anchor the base of the trunk to begin "growing" each tree

Work slowly as you felt your way upward. If you do not felt the fiber fully before you move along the trunk or branch, it will tighten, resist shaping, and not anchor deeply in the textile.

→ A long-stapled wool roving, such as merino, works best for the linear branches of a tree skeleton.

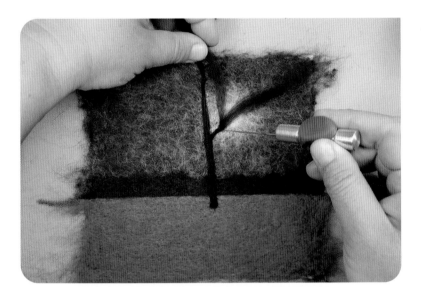

Add branches

Anchor a wisp of roving thoroughly along the trunk before slowly felting as you grow the limb.

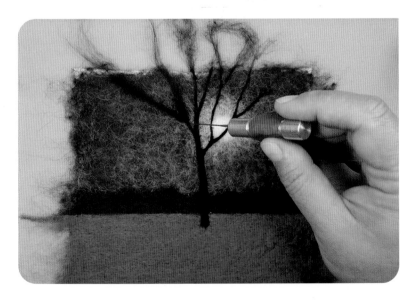

Divide roving for branches

Once you've anchored the wisp, you can cleanly separate the fiber of long-stapled roving in the middle of a trunk or limb to continue felting into smaller, finer branches.

Complete the bare trees

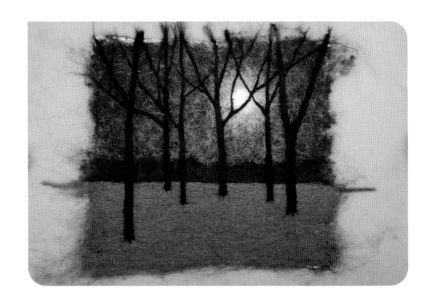

Add navy shadows to trees

Anchor a long-stapled navy roving at the base of each trunk, leaving the rest loose. This way you can play with the angles of all the moonlight shadows until it feels right, before anchoring them all in place.

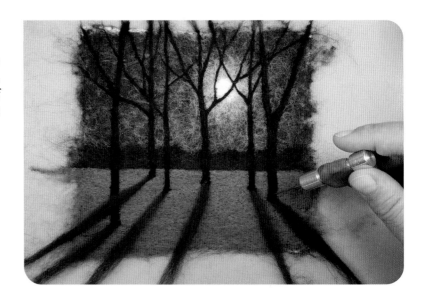

Felt navy tree shadows in place

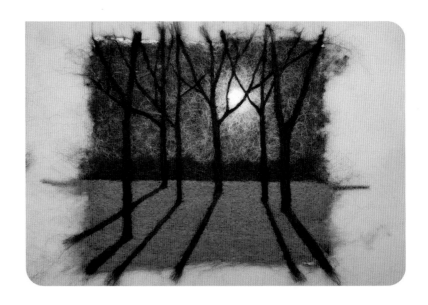

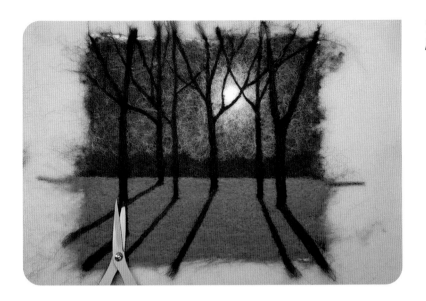

Trim away any navy that crossed a black trunk

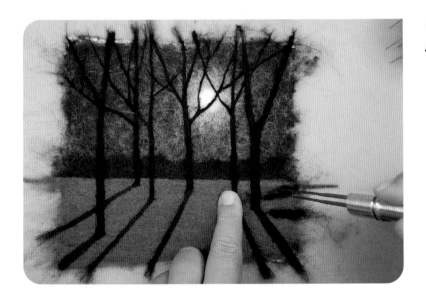

Create one evergreen in the right foreground, and one in the left background

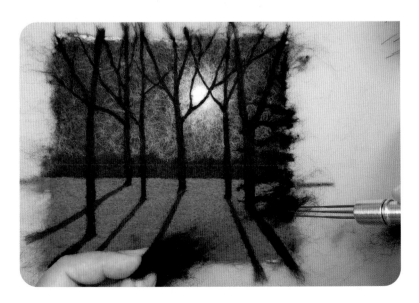

Build your evergreen branches

Use batt-style black wool for texture here if you have it. Starting to the right with the bottom branch, the widest part of the tree, imagine the trunk is just off-frame. Continue adding narrower branches as they move upward, varying the shape and texture of each branch, using a single needle.

Add the left background evergreen

Begin with a very narrow trunk here, rising from the horizon, then add branches by using small bits of wool and a single needle for an open and organically irregular tree shape.

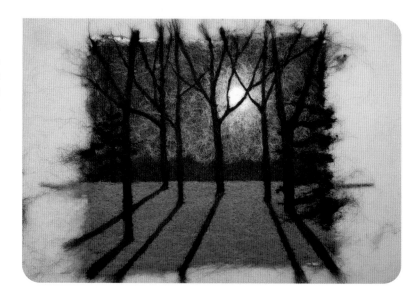

Add subtle shadows for evergreens

Add very light navy shadows to the evergreens, angling outward in the moonlight off the edge of your composition.

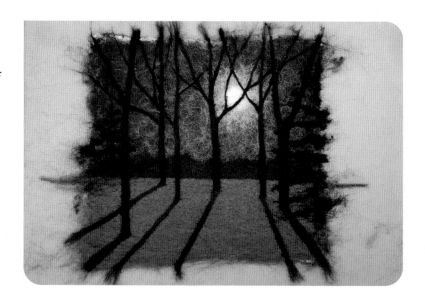

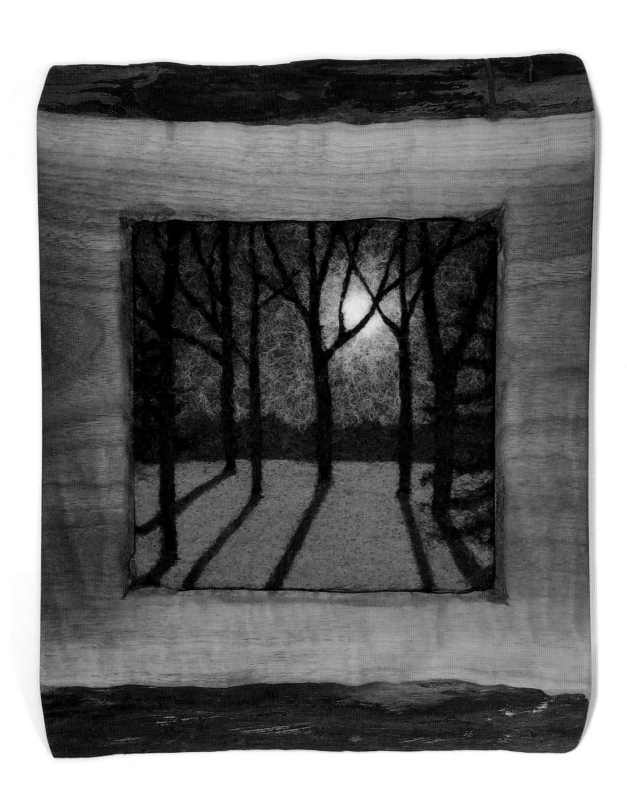

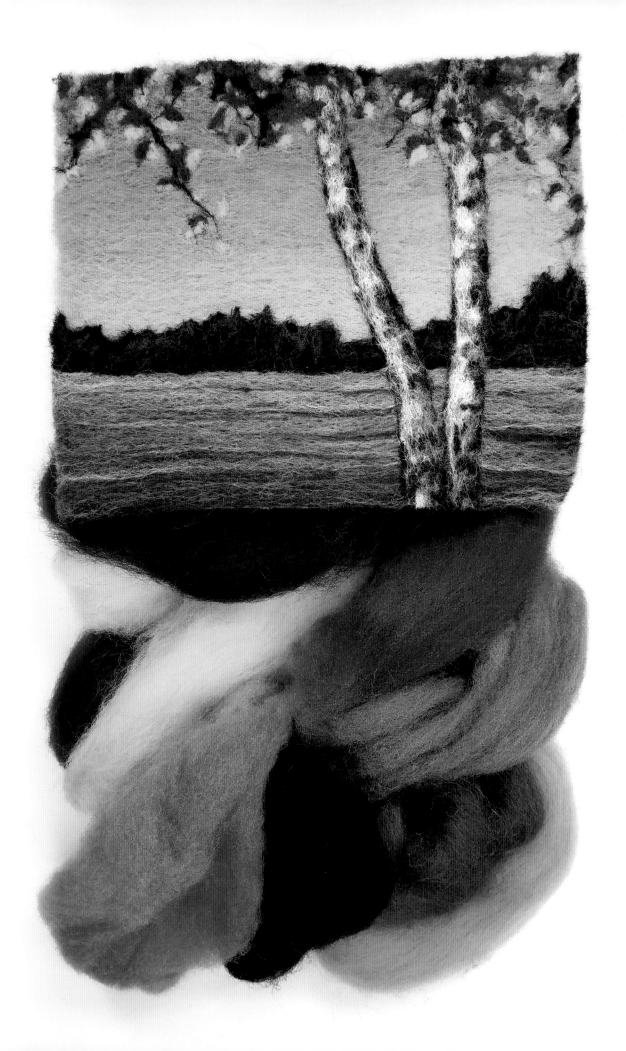

BIRCH LAKE

Water has as many moods as the weather, from a still mirror image to whitecapped waves. With Birch Lake we use wisps of roving to suggest just a bit of movement across the surface, hinting at the depths as well as the reflections. After we have anchored the distant shore with a simple treeline, the birch tree offers us some new tools and techniques, using snips from sharp detail scissors to create the textured surface of the bark, draped with backlit branches.

SUGGESTED MATERIALS

- 8 roving colors, as outlined in the wool chart for this project
- Foam work surface (8" × 10")
- Craft felt (5" × 7")
- 4 head pins
- Single felting needle (with or without handle)
- 6- or 4-needle holder, or both (as a blending tool)

Suggested Wool Chart

Color Key:

B1: Navy
B3: Lake
B7: Brite Sky
B8: Light Blue
B9: Ice Blue
N1: Black
N5: Med Gray
N8: Natural White
G3: Vibrant Leaf
W8: Neon Yellow

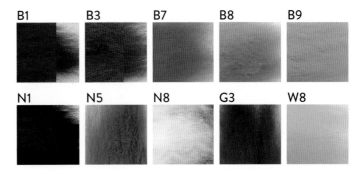

B1 B3 B7 B8 B9

N1 N5 N8 G3 W8

Divide composition for a visual guide

Guide your composition with marks along the edge of your foam block. Mark your horizon line first on both sides, one-third up from the bottom of the felt. Above the horizon line is the sky section. Divide this area into three even bands to guide the progression of three values of sky blue.

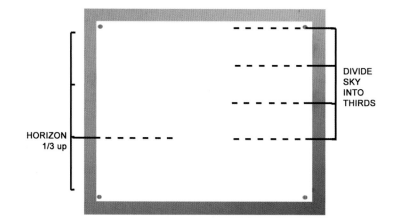

Felt the sky in three sections of blue

Beginning with the deepest value of bright sky blue, blend into middle light blue, then ice blue to the horizon.

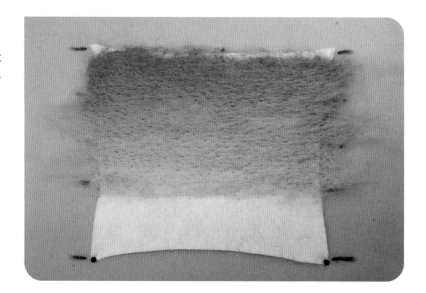

Felt the water area with solid lake-blue wool

Water, whether still or whitecapped, tends to be several shades deeper than the sky, so plan your color range accordingly.

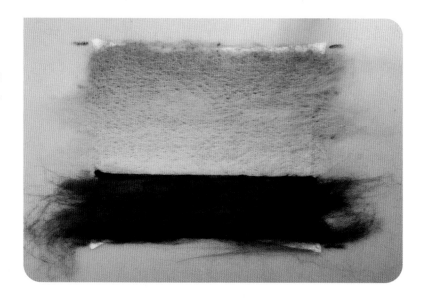

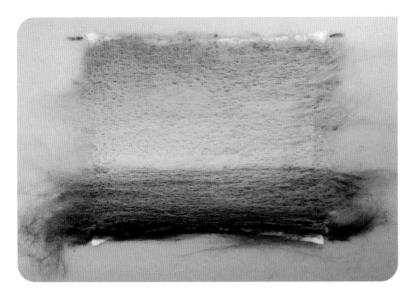

Add depth and reflection to the water

Overlay loose fans of roving, starting with navy toward the bottom, blending smoothly upward to the horizon with lighter values.

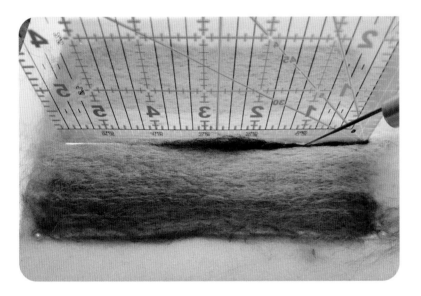

Establish a horizon line between water and sky with black wool

→ You can use a clear ruler for a straight-line shortcut; hold ruler firmly upright against the foam at the horizon. Being careful not to move the ruler, slide the needle down the clear acrylic repeatedly into a wisp of wool to complete a straight line across the piece.

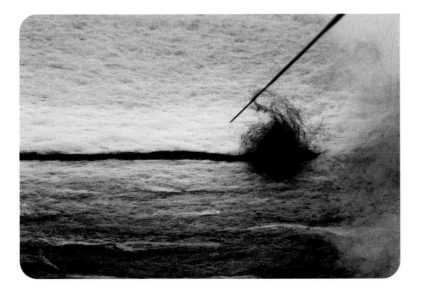

Add a treeline with nested black wool

Vary the shape and height of the treeline silhouette

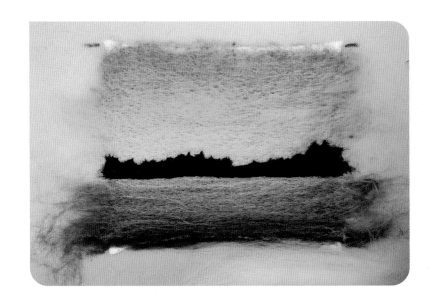

Add dark-green highlights across treeline for subtle volume

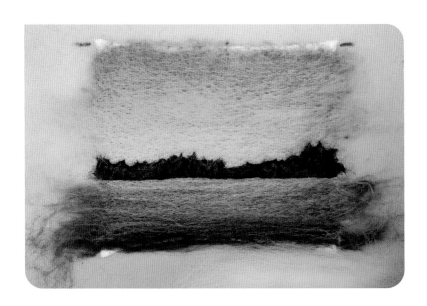

Create movement in the water

Beginning with navy roving, add long streaks horizontally, staggered across the surface of the water. Add larger streaks toward the bottom, where the waves should appear closer, growing finer and narrower as you move upward.

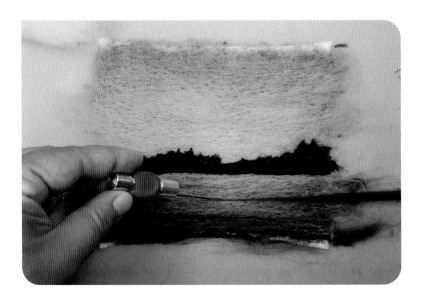

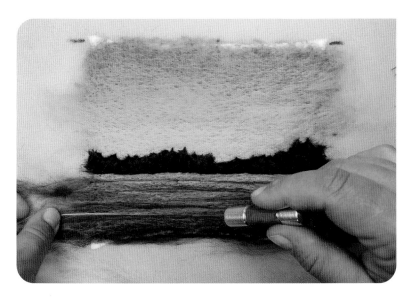

Add whitecap/highlights with white roving

At the top of each horizontal navy streak, add a narrow streak of white with a single needle.

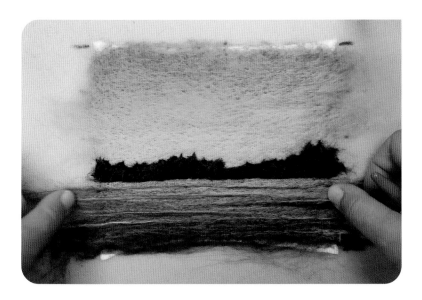

Add navy and white as needed to complete the water effect

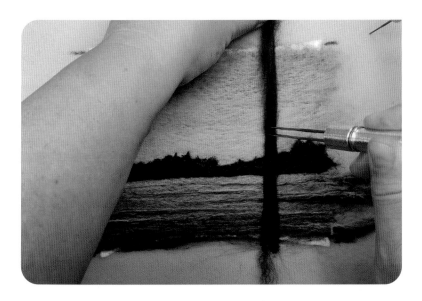

Start a birch tree trunk in solid black roving

Felt the trunk beginning one-quarter of the way across the composition from the right side, felting thoroughly to "grow" the tree from the bottom edge to the top.

Add a slightly narrower trunk to the left of the first

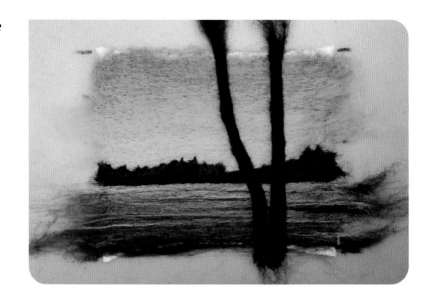

Nest bits of neon yellow for the "backlit" foliage

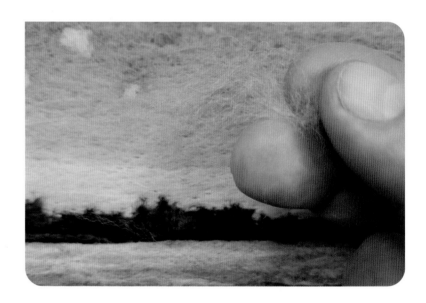

Anchor the small nested bits across the top edge to create a canopy

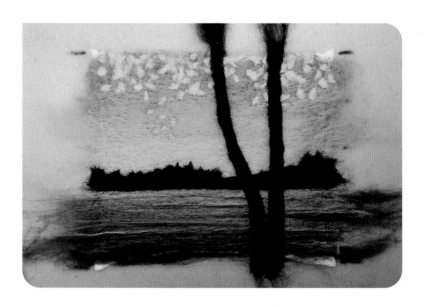

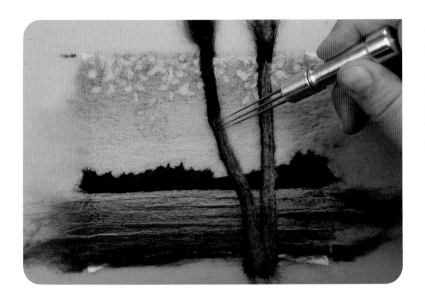

Loosely felt a medium gray vertically over the black trunk

When adding the highlight gray and white roving to the birch trunk, leave it somewhat loose and do not completely felt the fiber. The technique will require that some elasticity stays in the fiber for later felting.

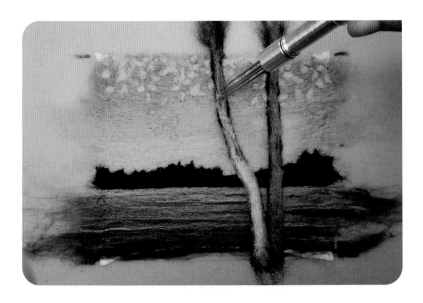

Loosely felt white/natural wool over the gray, but slightly narrower

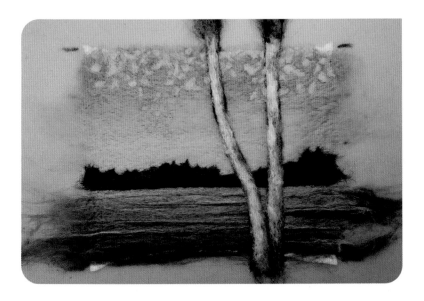

Leaving the base of the trunks darker adds realism

Snip through layers to create striations of birch bark

Begin snipping though the gray and white layers only (not the black layer) with small horizontal cuts, using sharp detail scissors. Snip from left and right at staggered intervals. After snipping, felt the trunk with a four-needle tool, up and down the trunk, to see how much of the black is revealed.

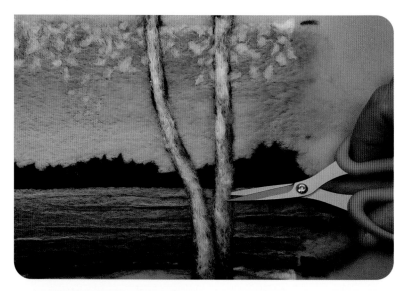

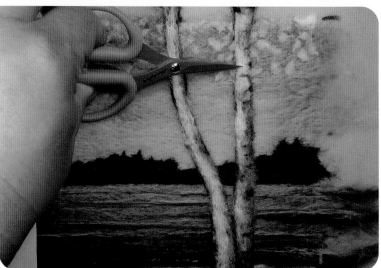

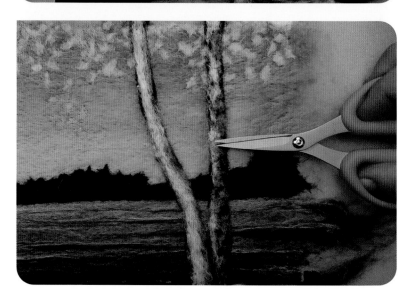

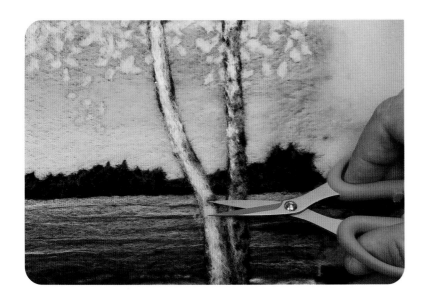

Snip, felt, and reveal the black underneath until the bark appears textured

If you still see too much white, snip more or use a single needle (or both) to felt the cut ends back from the snips.

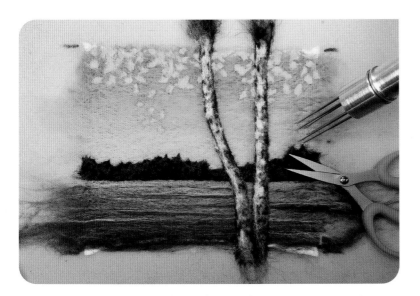

Add delicate branches through the leaves

With a single needle and a pinch of fine, long-staple roving (merino works great here), grow the branches down from the top of the frame to visually anchor the leaf canopy.

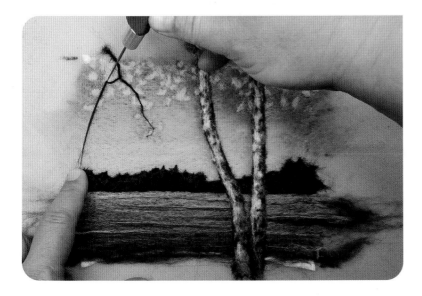

Add small nested bits of green wool leaves throughout the neon-yellow canopy

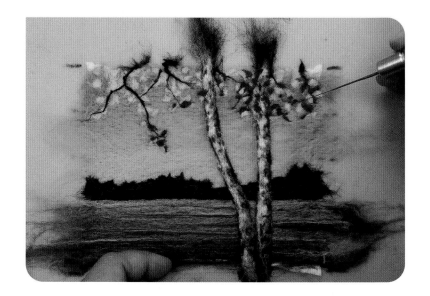

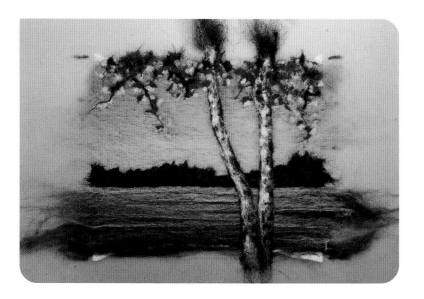

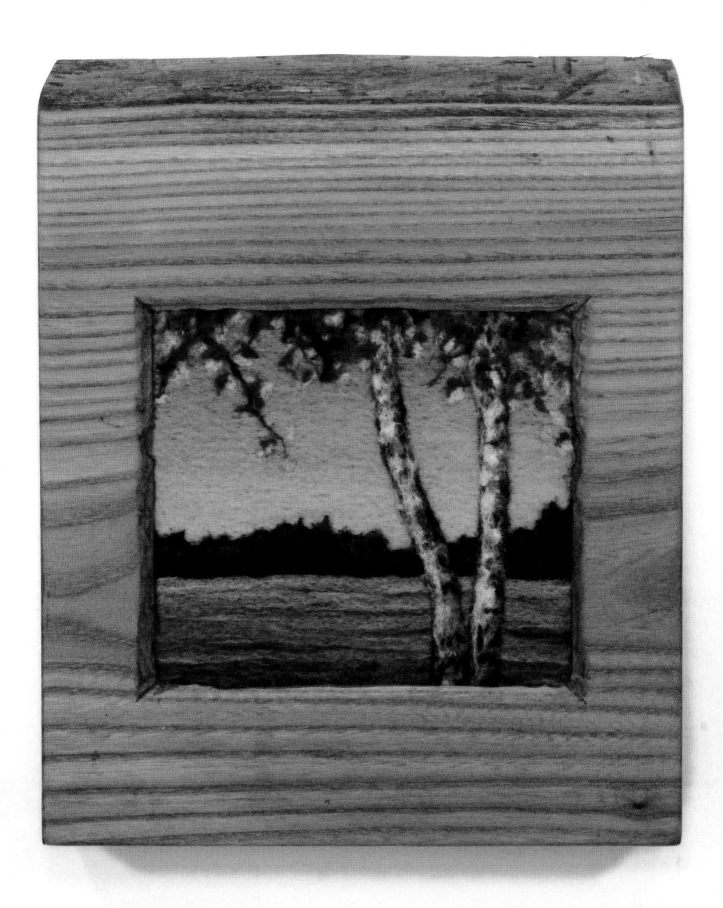

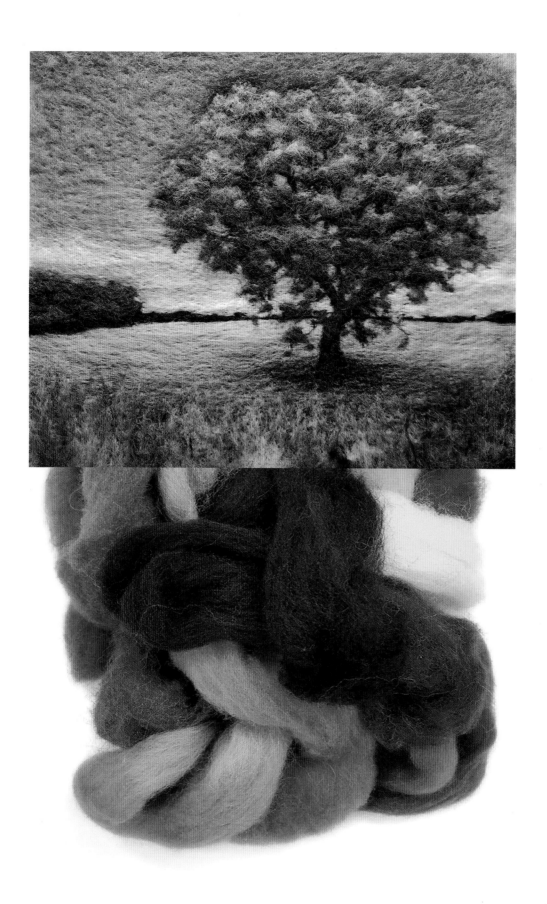

LONE OAK

When I see a single, dignified old tree in a field, it always seems to hold some secret wisdom. Here we give it the respect it deserves by simplifying the background and focusing our efforts on anchoring that tree with deep ground shadow before growing it from the trunk upward. We take the time to build the entire skeleton of branches before adding clusters of vibrant foliage, with the sky peeking through.

SUGGESTED MATERIALS

- 15 roving colors, as outlined in the wool chart for this project
- Foam work surface (8" × 10")
- Craft felt (6" × 8")
- 4 head pins
- Single felting needle (with or without handle)
- 6- or 4-needle holder, or both (as a blending tool)

Suggested wool chart

Study your reference photo and assemble roving for the project.

Color Key:

B4: Deep Sky
B7: Brite Sky
B8: Light Blue
N1: Black
N8: Natural White
G2: Deep Forest (B)
G4: Grass Green (B)
G8: Brite Moss
G9: Bronze
G10: Toffee
W1: Chocolate
W3: Wine
W6: Blaze Orange
W7: Gold
W9: Lemon Yellow

B4	B7	B8	N1	N8
G2	G4	G8	G9	G10
W1	W3	W6	W7	W9

Template for tree skeleton

When "building" a tree in wool, it's helpful to have a sketch of the branch structure for reference.

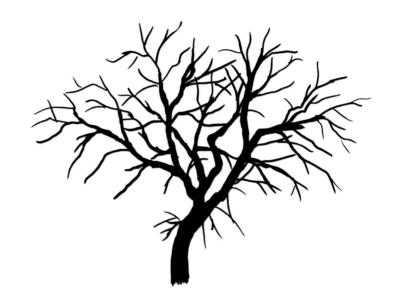

Felt the sky in three sections of blue

Beginning with the deepest value of deep sky blue, blend into middle light blue, then ice blue to the horizon. Always focus on the dark layer first, then build and blend lighter values on top.

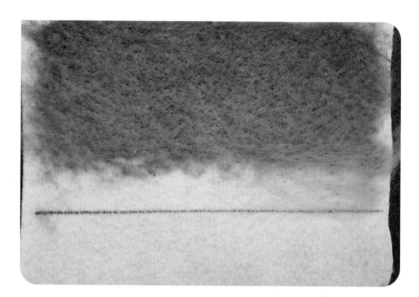

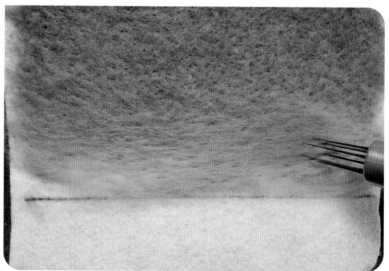

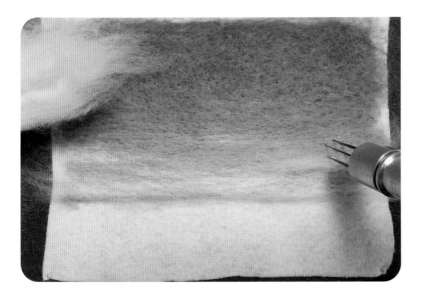

Use natural-wool roving for an atmospheric cloud haze at horizon

Anchor delicate fans of white/natural roving with a multi-needle tool horizontally above the horizon.

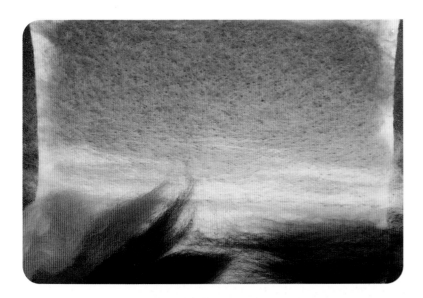

Assemble the range of colors of the field underpainting

Since we're aiming for a more muted field in this piece, as opposed to a vibrant field, our underpainting choices will have a bit less contrast to the finished grass colors (i.e., they are not *directly* across the color wheel).

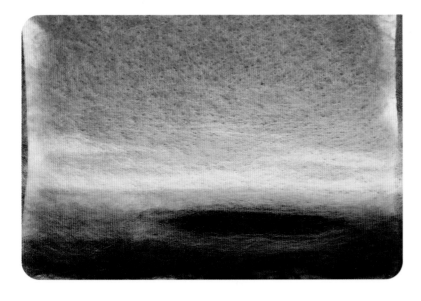

Establish the tree shadow before beginning the tree

To effectively "ground" the shadows of your tree in the field, leave darker tones of the underpainting where the trunk and tree canopy will eventually shade the field.

Add a small grouping of trees in distance

To create a focal point in the distance, add a small treeline or grouping to the left side at the horizon, first with black and then highlighting subtly with deep green.

Finish distant half of field first

Because you want the field tones to be complete in the background before it ends up behind the tree trunk, you will finish the lighter tones of green and yellow from halfway up the field to the horizon line. The foreground of the field will be finished after the tree is complete. Be sure to leave the shadow tones exposed on the ground under the tree.

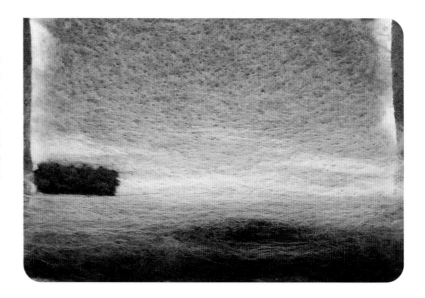

"Plant" your tree trunk in the center of the shaded ground area

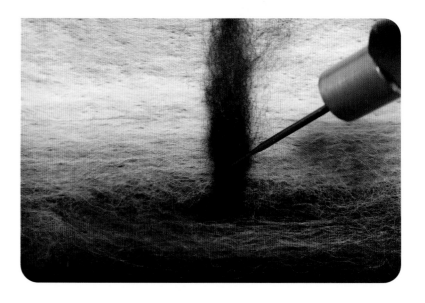

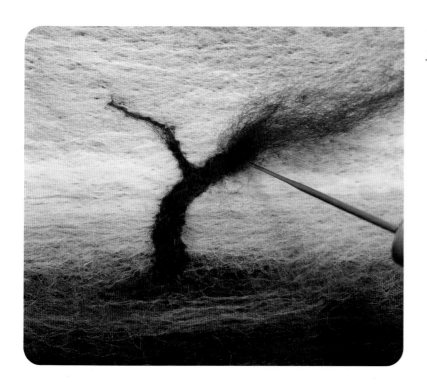

"Grow" the tree trunk and branches, felting thoroughly as you move upward

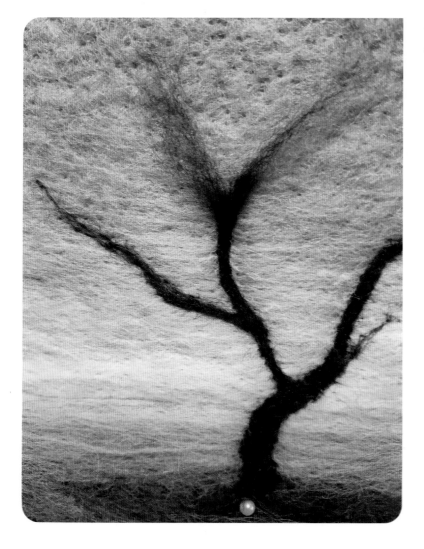

Divide the roving or add wisps for fine branches, using a single needle

Snip shorter lengths of roving for shorter branches

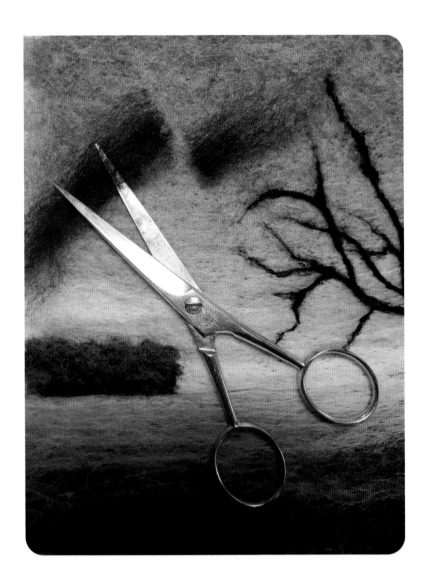

Highlight the tree trunk

Use a single toffee brown to highlight the center of the trunk where it will show below the (eventual) foliage.

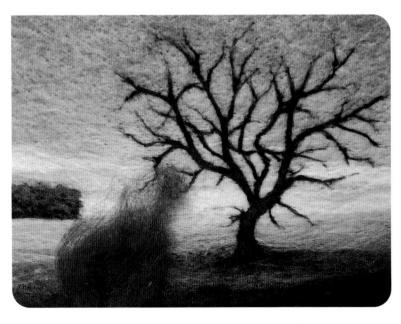

Block in clusters of foliage

With small nests of black wool, start blocking in clusters of foliage. Avoid too much detail here and maintain plenty of negative space (sky) between the boughs.

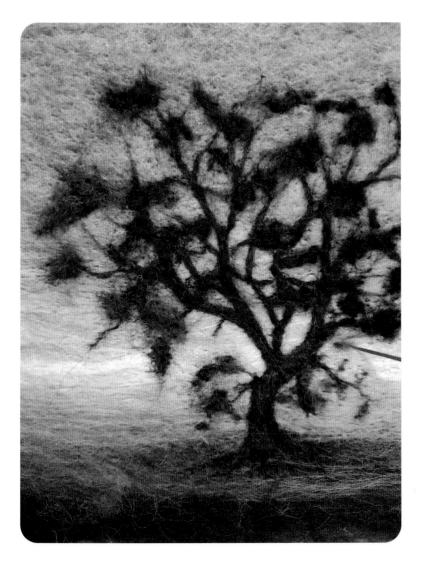

Begin highlighting foliage with deepest green

Within each black cluster, add a nest of deep green. With each progressively lighter value of green, make it slightly smaller than the darker tones below it, to create shading and volume.

Add the medium values of green

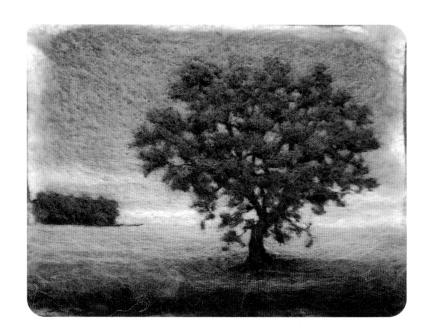

Finish the lightest-green to yellow highlights

As you add the brightest highlights, concentrate on the parts of the foliage hit directly by sun toward the top, and extended branches to the sides.

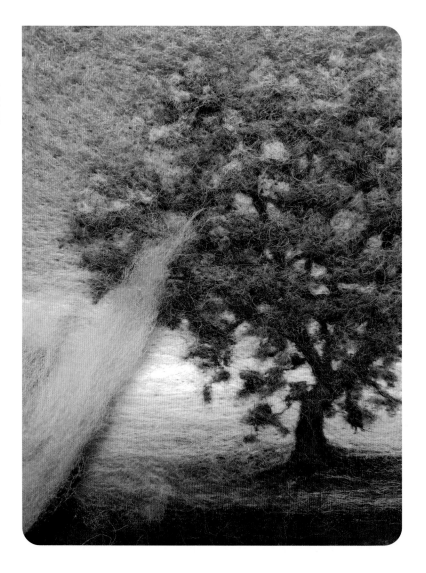

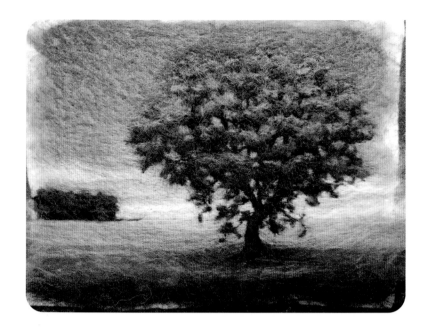

Completed highlights in the foliage

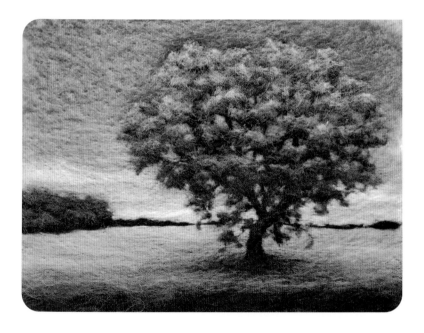

Finish the foreground with finger blending

Define the palette of roving tones for the foreground grasses

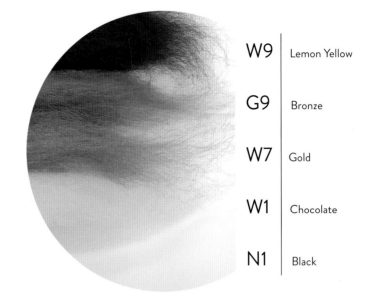

W9	Lemon Yellow
G9	Bronze
W7	Gold
W1	Chocolate
N1	Black

Pull wide, open fans of each tone to be blended

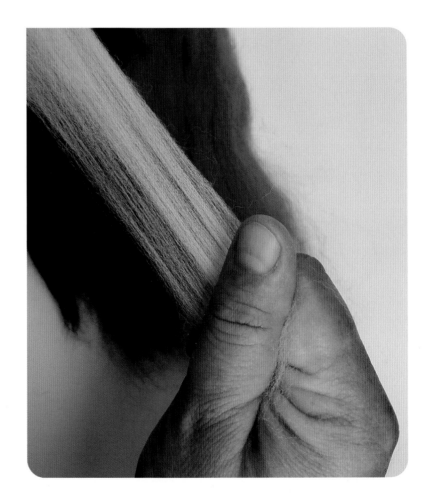

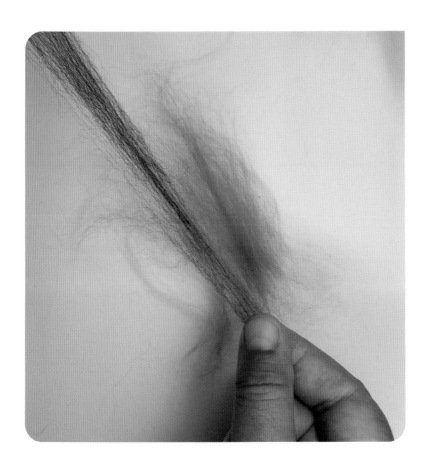

This technique requires long-staple roving rather than batt fiber

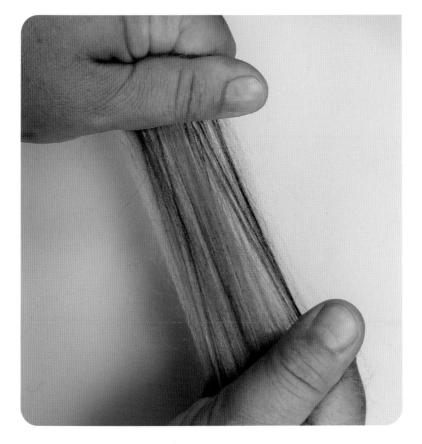

Pull the blend of roving apart, flip, and repeat to mix thoroughly

Assemble different tones for a variety of color swatches

Begin layering grasses

Laying loose fans of blended roving, begin with a six-needle tool at the bottom, felting upward until the fiber "shrinks" and tapers out naturally. Start with your darker blends and alternate with lighter swatches until you've achieved an irregular, natural grass texture.

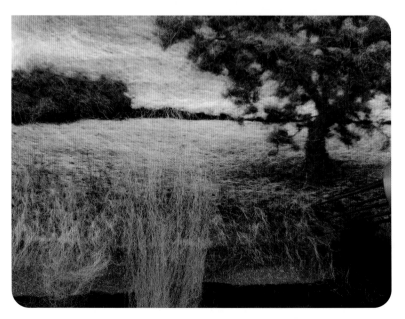

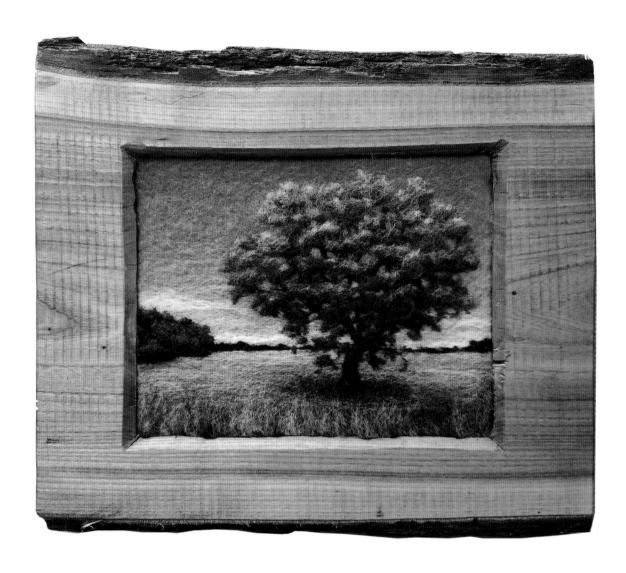

Why does my needle keep breaking?

Felting needles are brittle and can easily break when pushed at an angle or put under any sideways pressure. Always poke and pull the needle straight through the surface at the same angle. Never twist or bend your needle while felting or use it to "scoop" or push fibers around the surface. It won't take you long to learn the limits of the needle (and keep your fingers out of the way). Be prepared to break some needles; it happens to the best of us!

What do I do when the textile pulls off bits (or chunks) of foam?

Chunks of foam are embedded in the fiber in heavily worked areas, especially those with single-needle detailing. You can felt more lightly to avoid this, but I am willing to sacrifice some foam for a work of art, so I don't worry too much. A bit of foam left in the fibers in the back will not harm your work. To minimize this problem, when you remove your finished textile, pull very slowly, starting at the corners and pulling all the "easy" parts first, pushing down on the foam as you carefully pull the fibers away from the surface. Move your grip around as you pull so you don't distort only one area of the textile. If/when you have chunks of foam stuck in the backside of your textile, you can slide open embroidery scissors (not too sharp!) gently under the embedded bits of foam and lift the pieces out, or if that doesn't work, just trim the fiber and foam down to ¼" from the acrylic surface, like a crew cut. This will reduce lumpiness without detaching your textile from the base fabric. The textile gets distorted when it's pulled from the foam but will be blocked back into shape after it's removed.

What's with the needle holes?

Often, beginners are distracted by the needle holes permeating the surface of the textile, but when your textile is complete the holes will dissipate as you remove the textile and handle the fabric, and you simply don't notice them when you step back to take in the image and composition. Using mixed tones rather than one large area of a single fiber color will also help obscure needle holes; the shadows simply become part of the blend. If you're really bothered, try finer-gauge needles (40, 42, etc.).

OUCH@!%/*

Do not get visually distracted or look anywhere but at your hands while needle felting. I recommend keeping Band-Aids on hand, so you don't mess up your work if/when you poke your finger.

What if I'm allergic to wool?

Since wool is made of keratin, chemically the same as our own hair, what we might consider a wool "allergy" is typically an irritation response to the texture of stiff fiber ends poking from the wool. If you react to this scratchy texture, try working with the long, silky strands of merino to see if you have an easier experience.

Will my work fade?

If you avoid direct sunlight on your work and use properly dyed wool, your work will not fade. Strong wools have lasted centuries in antique rugs, and modern acid dyes are different than paint or surface pigment and penetrate deeply into the material, bonding within the fiber through chemical reaction. All lanolin and foreign matter are thoroughly cleaned from the fleece during processing, so it will not attract dust or moths or discolor over time.

Can I wear my work?

Needle felted wool textiles are not as durable as wet-felted fabric. If you would like to use your piece as a wearable element or in a high-friction application such as pillows or purses, try wet-felting your textile when the dry-felting process is complete. You will lose a bit of sharpness and detail, but the fabric will be more resilient for different uses.

How do I dust the textile?

The textile can be easily dusted by using a can of compressed air or by blowing and tapping on the surface to release small particles. It may be wispy on top, but a well-felted fabric image will not lose its structure. For extreme cleaning, unroll nylon screen over the textile and vacuum through it gently.

What's the best way to protect my work? (see "Will my work fade?" and "How do I dust the textile?")

The current chemistry of acid-dyed wools is very archival and lightfast. If you want to place your work in a directly sunny space or are generally concerned about extreme conditions or dust, talk to a framer about building a Plexiglas box frame, which will filter UV rays for total dust and light protection.

Can the work be attacked by moths?

My research and personal experience tell me that fabric moths do not bother with well-lit, well-aired, clean fibers. A dirty old sweater in the back of the closet is a moth feast, but I have had no problems with my wool materials or finished works since they are free of oils and dirt. If storing your textile, seal the piece in a clean, airtight bin or bag.

How do I frame my textile?

Wool is such a tactile and elemental material that it plays in interesting ways with a variety of framing materials; glass, metal, found objects, and, of course, wood. If you need to adhere the textile, I suggest PVA glue for an archival fix. Experiment with ideas such as gluing to a metal object, creating a floating textile pressed in soldered glass, or wrapping entirely around a frame for a waterfall effect. I love wood, or course, but encourage you to find your own style and signature if you intend to create a name for yourself as an artist.

→ For frames (as well as tools and roving kits), please visit my website: www.jaanamattson.com

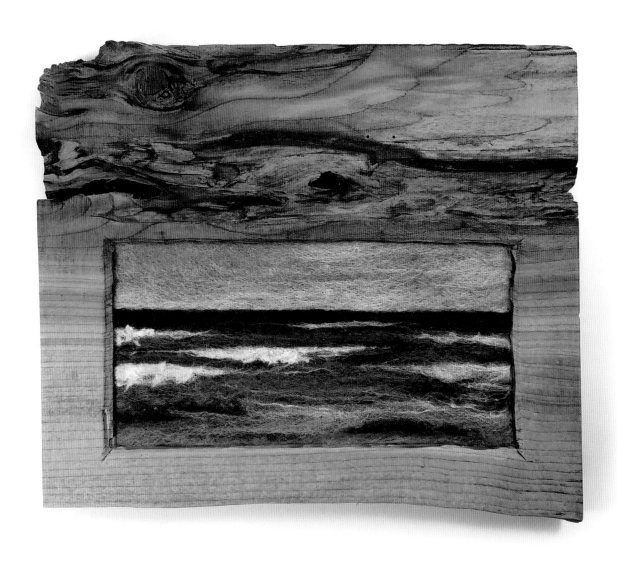

Opposite: **Sailboat in the Shallows**, 2019, wool, maple,
14.5" × 8.25" × 1.75"

Waves in Knotted Cedar, 2018, wool, cedar,
12" × 13" × 1.5"

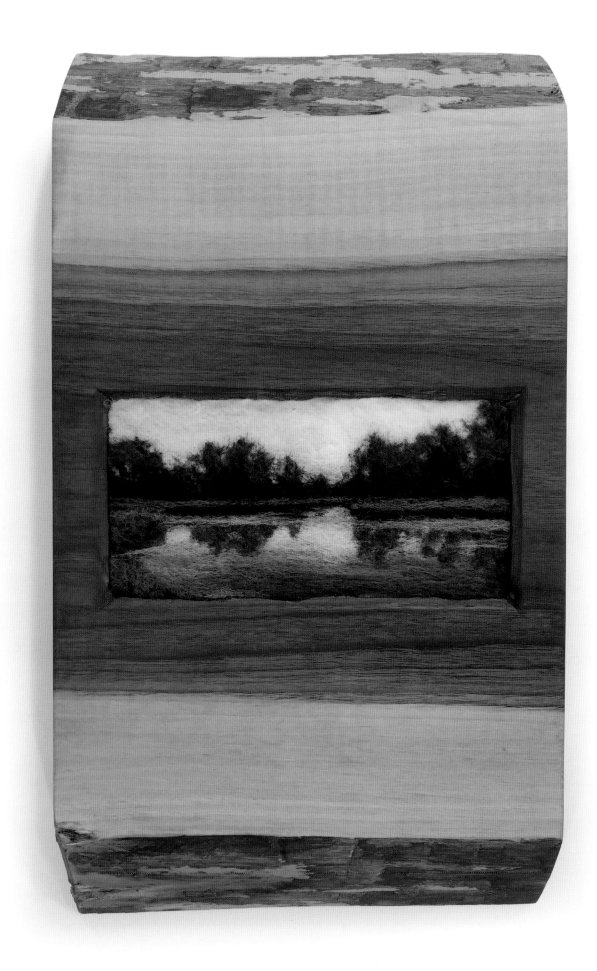

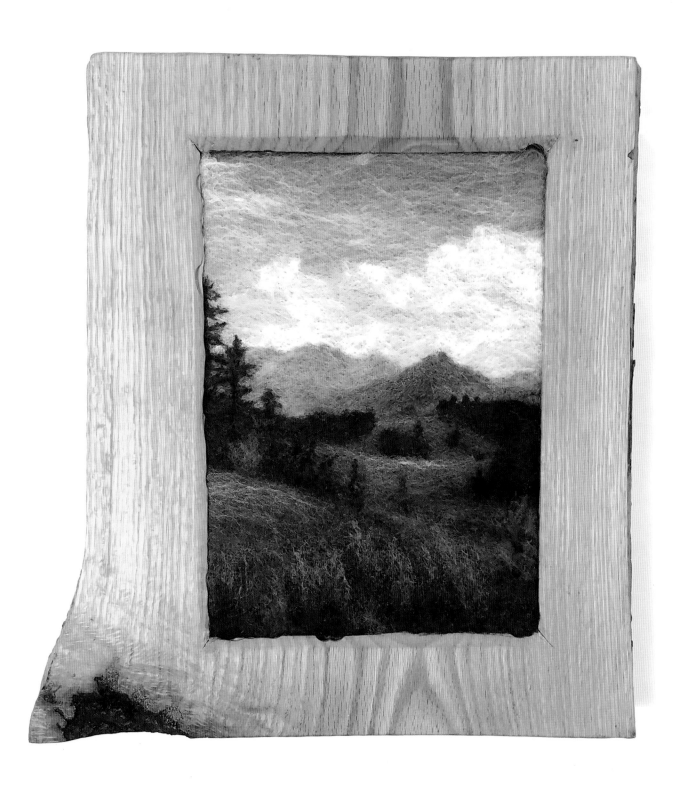

Opposite: **Stillness on the Pond**, 2017, wool, walnut,
21" × 14" × 1.75"

Blue Ridge Mountains, 2019, wool, elm, 12.5" × 12" × 2.5"

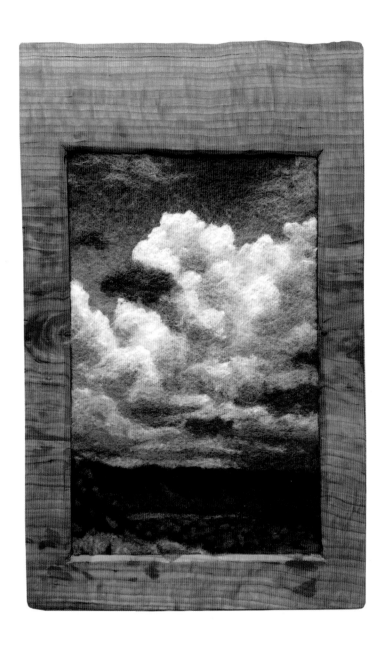

Left: **Southwestern Thunderhead**, 2018, wool, cherry,
27" × 18" × 2.5"

Right: **Purple Dusk on the Marsh**, 2015, wool, walnut,
17" × 22.5" × 1"

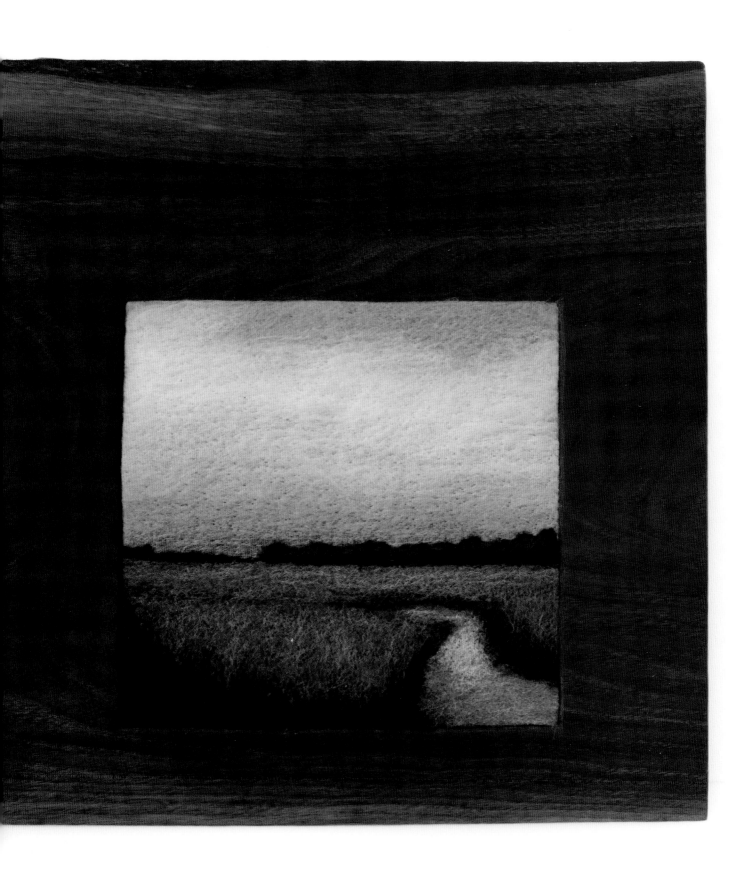

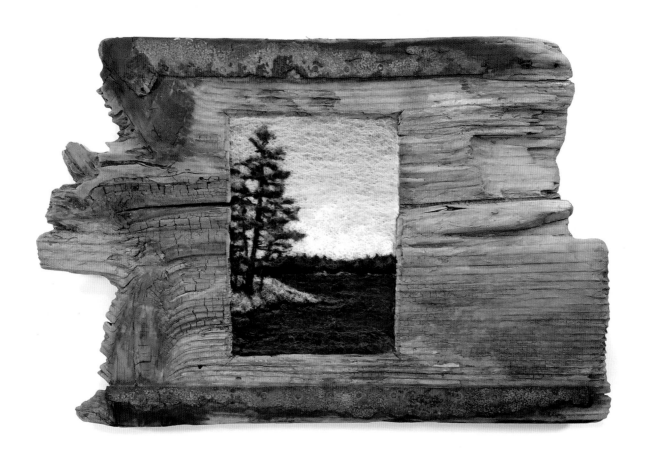

North Shore in Driftwood, 2019, wool, driftwood plank,
10" × 13" × 1"

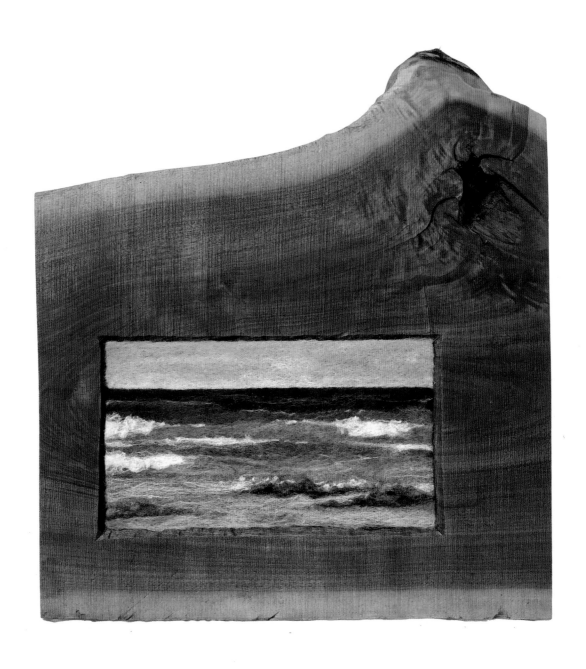

Cresting Waves in Burled Slab, 2017, wool, cedar,
16″ × 17″ × 1.5″

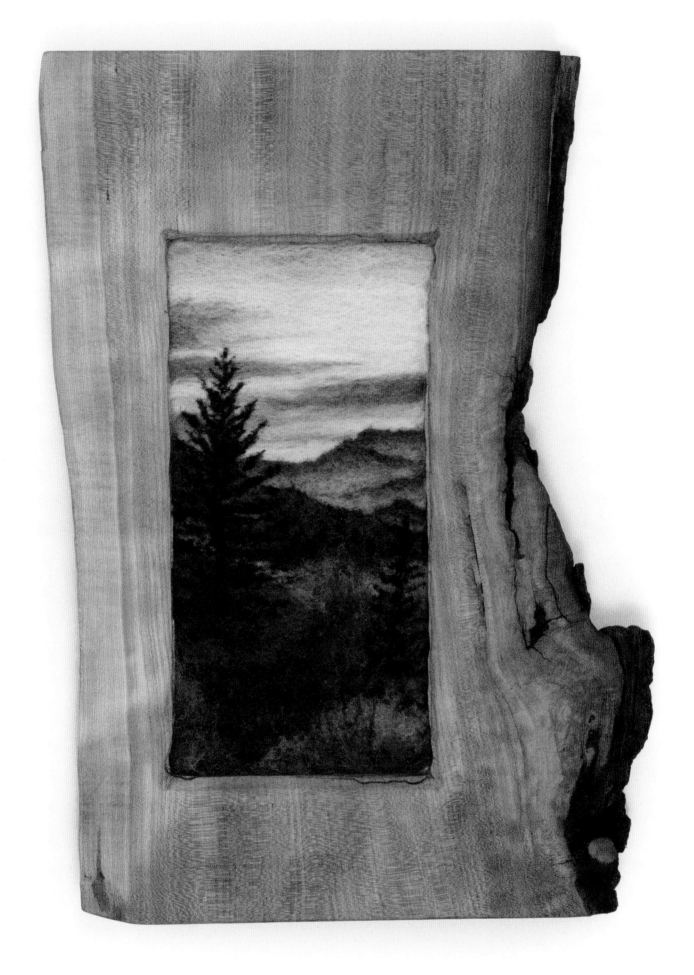

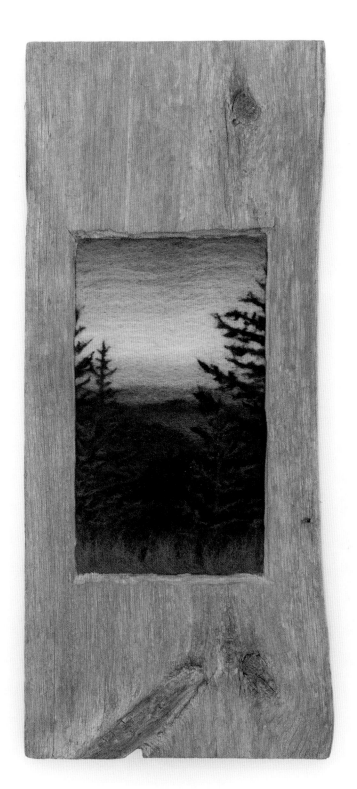

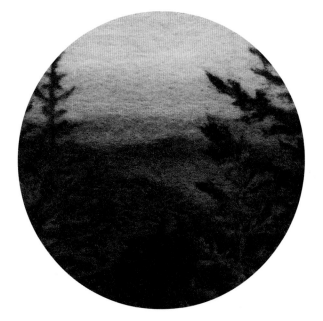

Opposite: **Mountain Sunset**, 2018, wool, maple,
14" × 10" × 3"

Pale Mountain Sunset, 2019, wool, barnwood,
18" × 7" × 1"

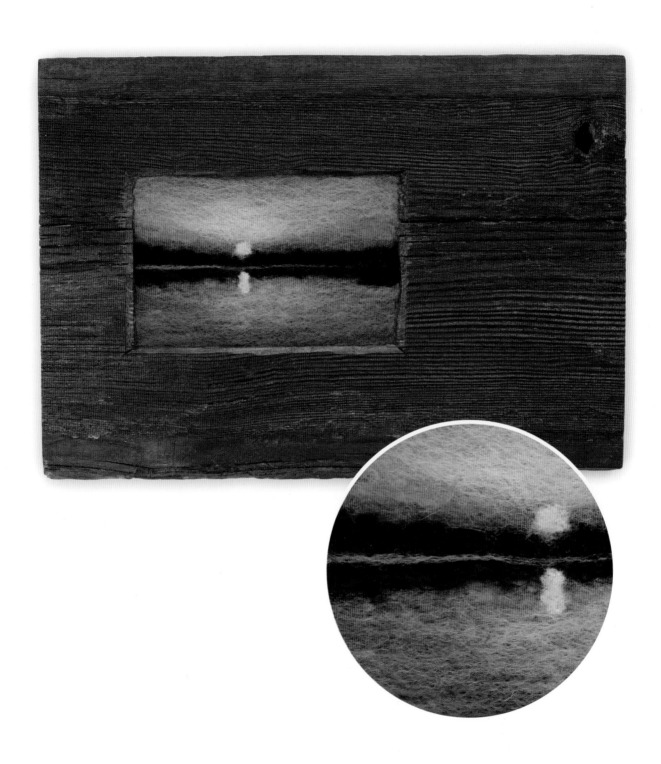

Setting Sun Reflections, 2018, wool, barnwood,
14" × 10" × .75"

Opposite: **Great Lake Vista**, 2017, wool, walnut,
18" × 6" × 1"

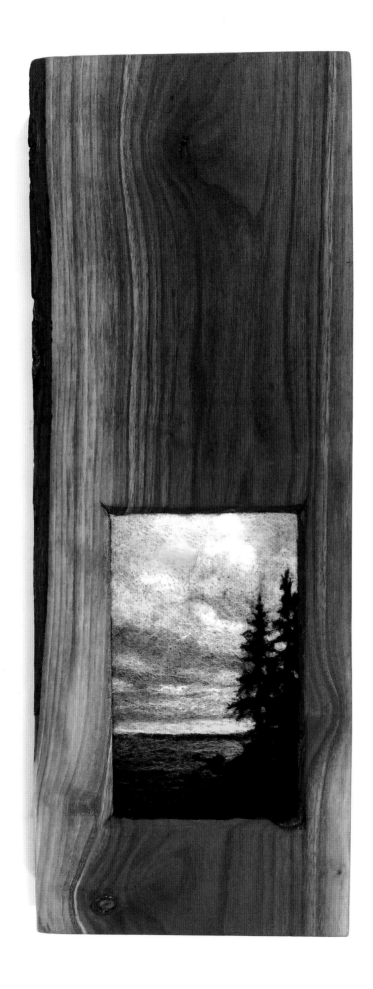

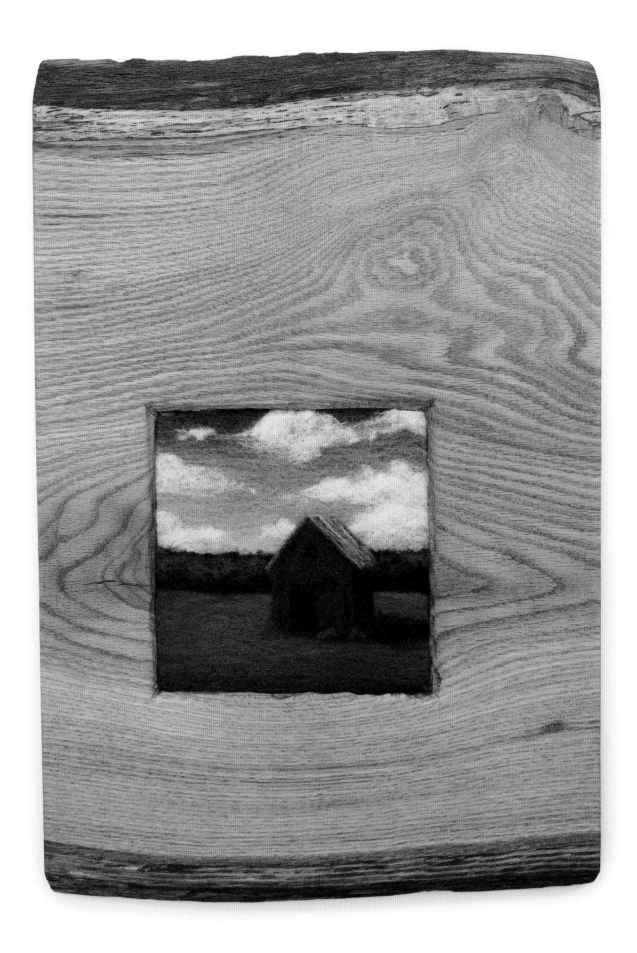

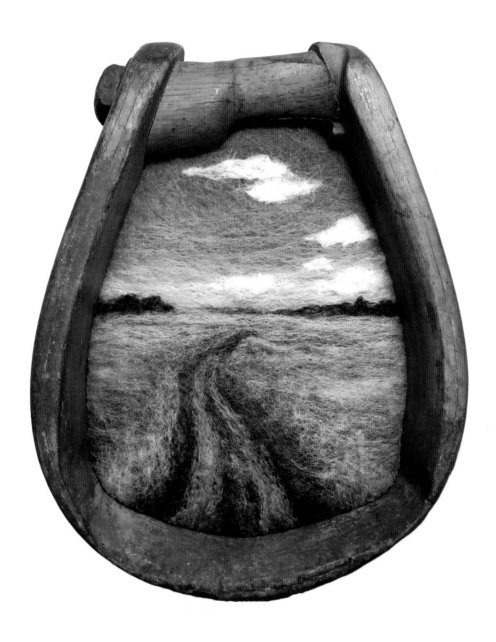

Opposite: **Square Barn**, 2019, wool, oak,
21" × 16" × 1"

Winding Road in the Grasses, 2018, wool, antique stirrup,
8" × 6" × 2"

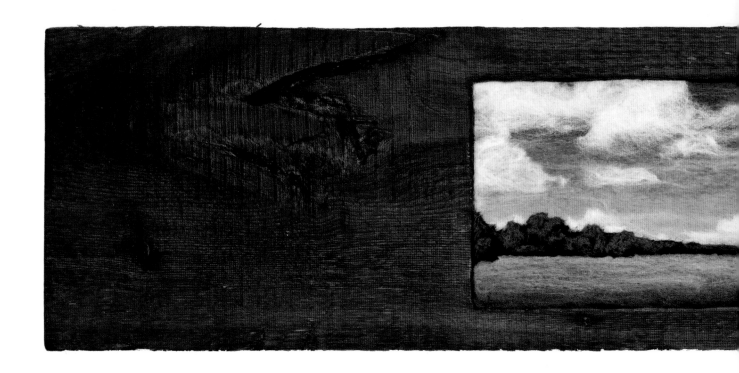

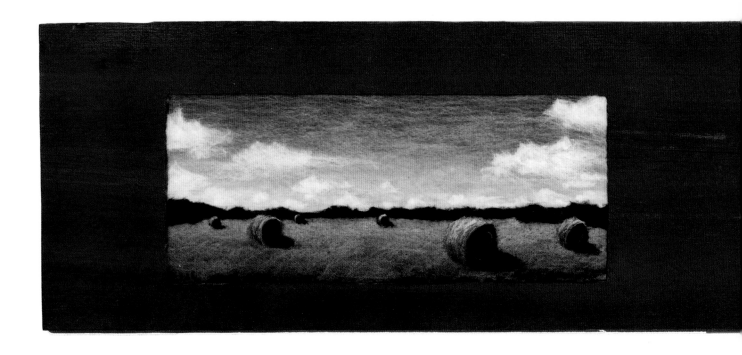

Top: ***Clouds in the Wind***, 2014, wool, barn
timber, 10″ × 44″ × 2″

Bottom: ***Hay Bales in Red Barn Door***, 2014, wood,
barnwood, 12″ × 45″ × 1″

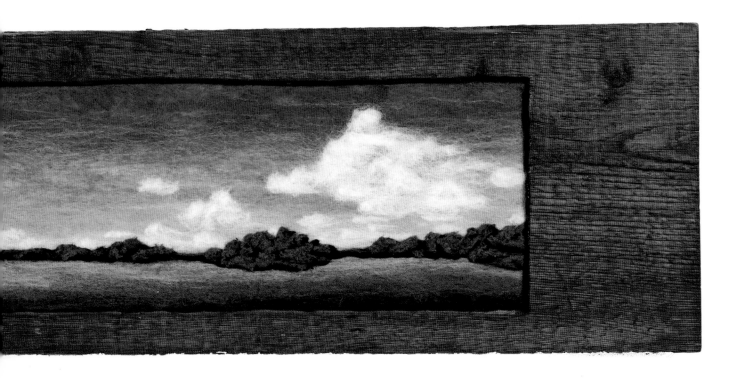

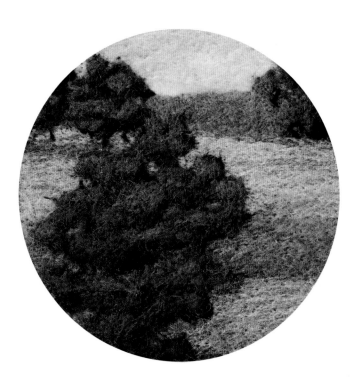

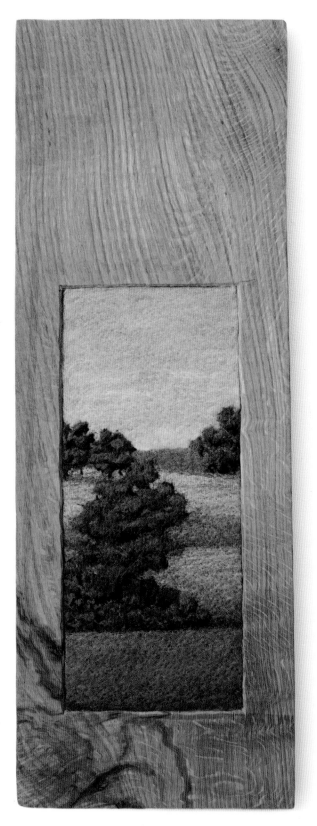

Hills of Gold, 2016, wool, wood,
29" × 10" × 1"

Opposite: **Hay Bales in the Sun**, 2017, wool, walnut,
24" × 15" × 1.25"

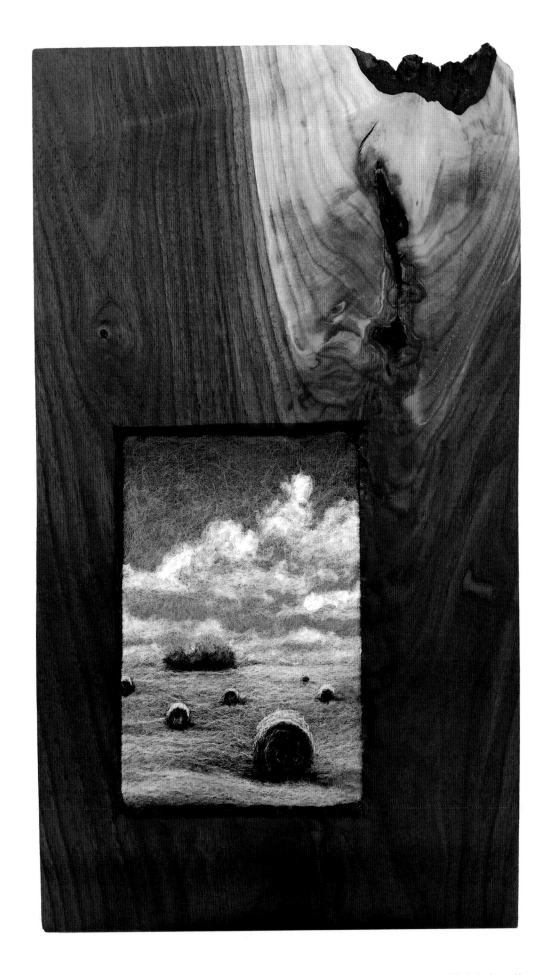

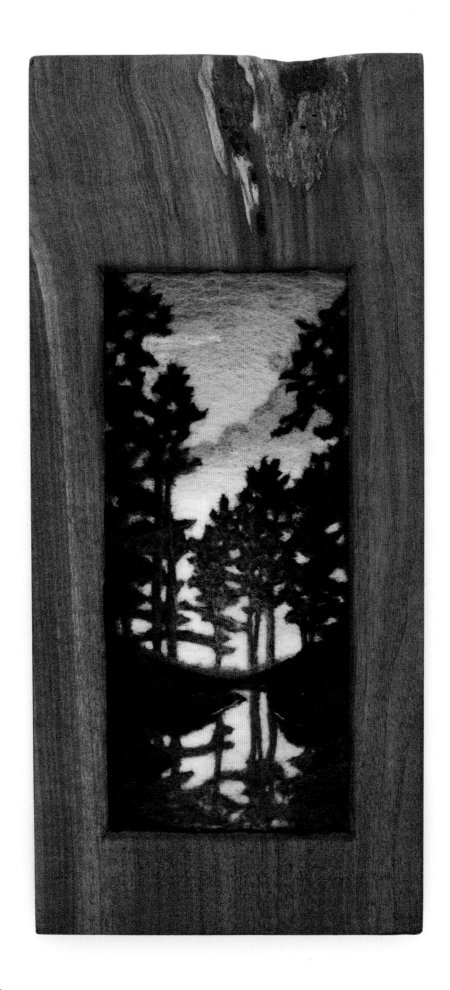

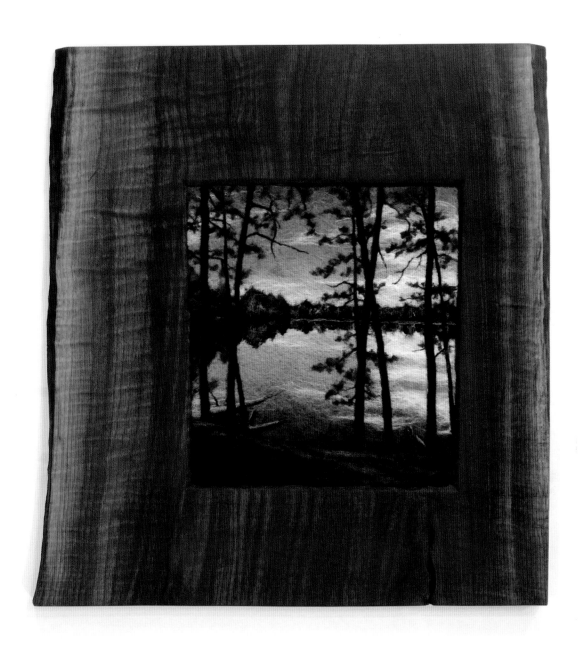

Opposite: **Forest Silhouette at Sunset**, 2019, wool, walnut,
23.5" × 10.5" × 1.5"

Northern Reflections (Scenic State Park, MN), 2017, wool, walnut,
21.25" × 20.5" × 1"

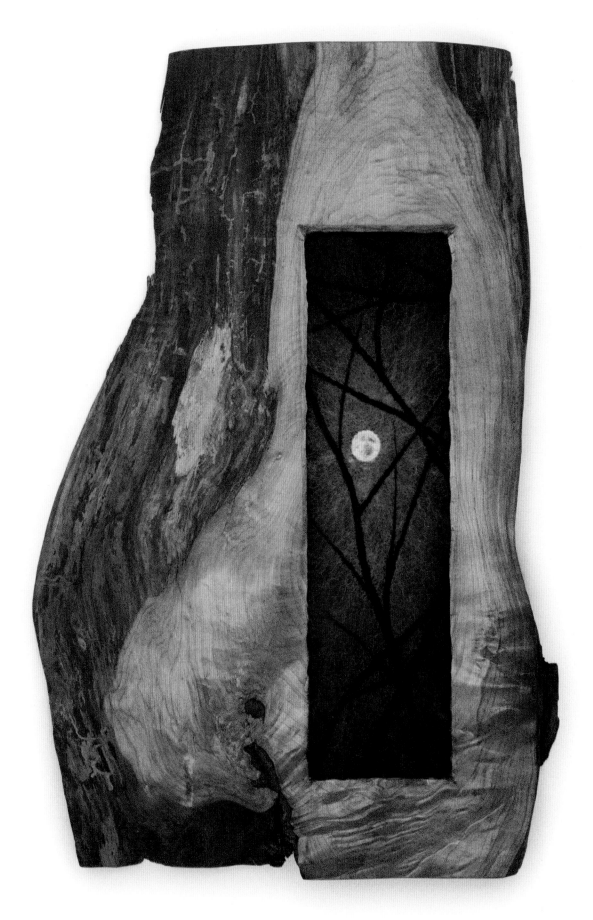

Moon Branch Sky, 2018, wool, maple,
23″ × 11″ × 1.5″

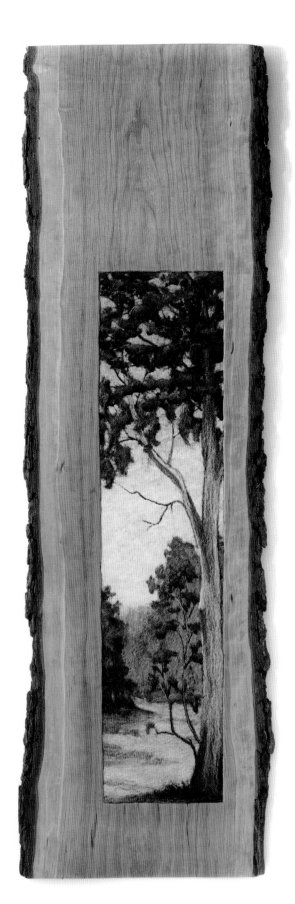

Eucalyptus Grove in Live-edge Cherry, 2015, wool, cherry,
65" × 21" × 1.25"

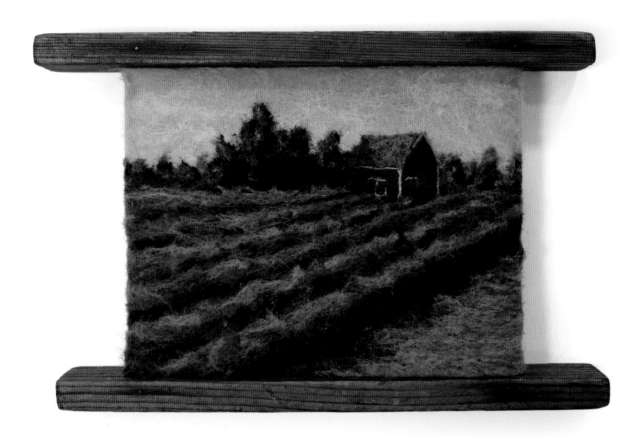

Lush Furrows and a Red Barn, 2018, wool, antique winder,
8" × 12" × 1.75"

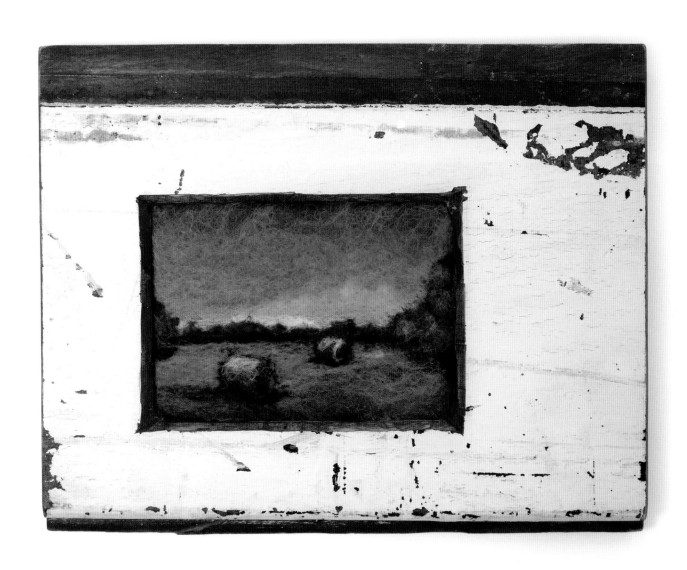

Haybales in White, 2017, wool, reclaimed baseboard,
7" × 9" × .75"

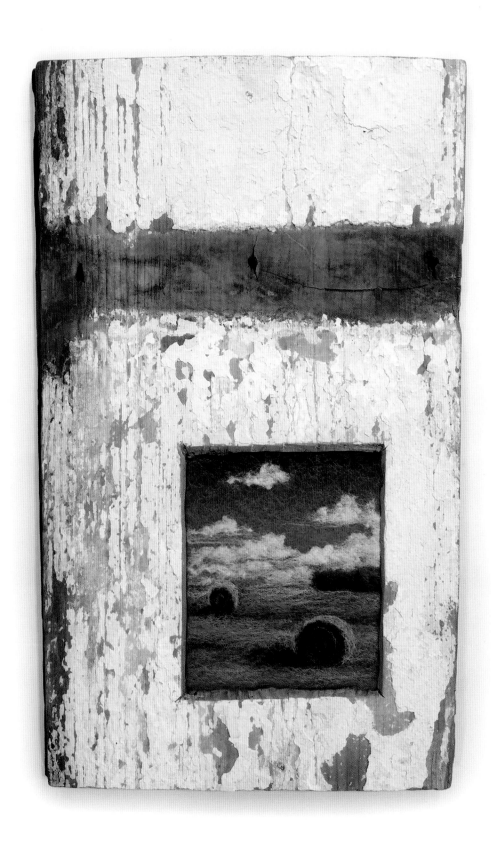

Haybales in Whitewash, 2018, wool, reclaimed barnwood,
14″ × 8″ × .75″

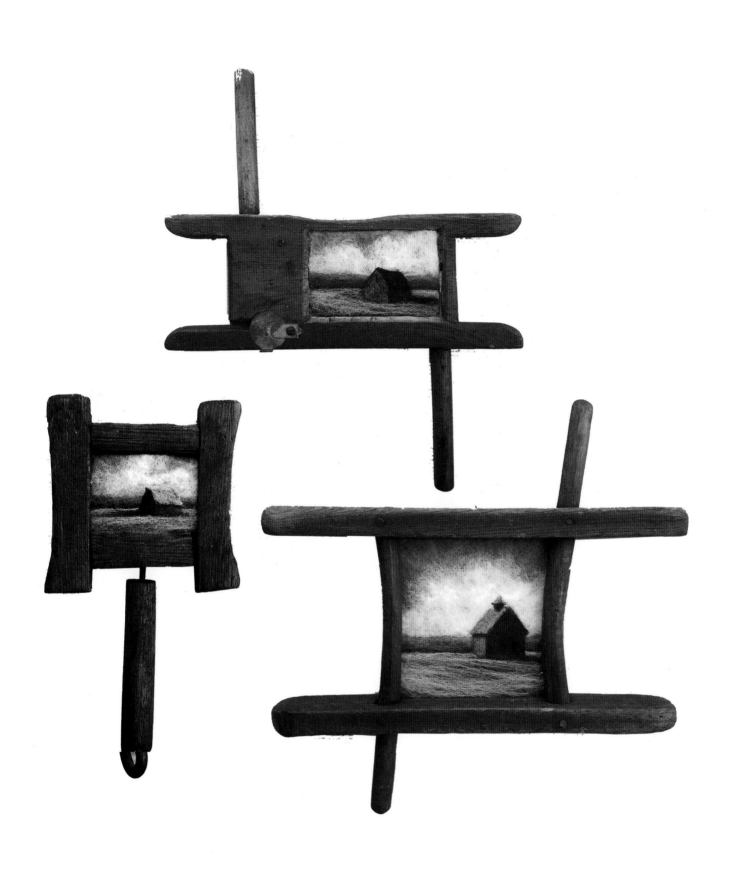

Red Barns in Antique Winders (grouping), 2017, wool, antique winders, largest:
14" × 12" × 1.75"

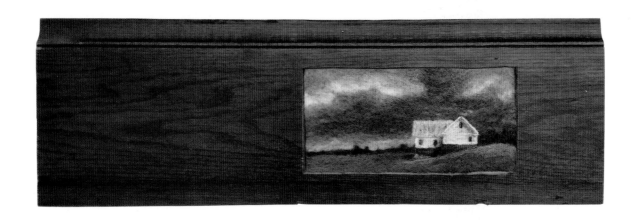

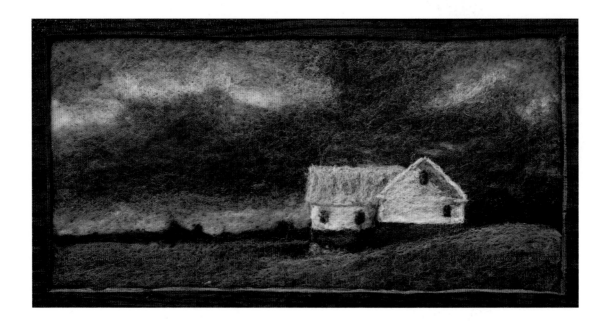

Impending Storm on the Farm, 2015, wool, oak baseboard,
10" × 24" × 1"

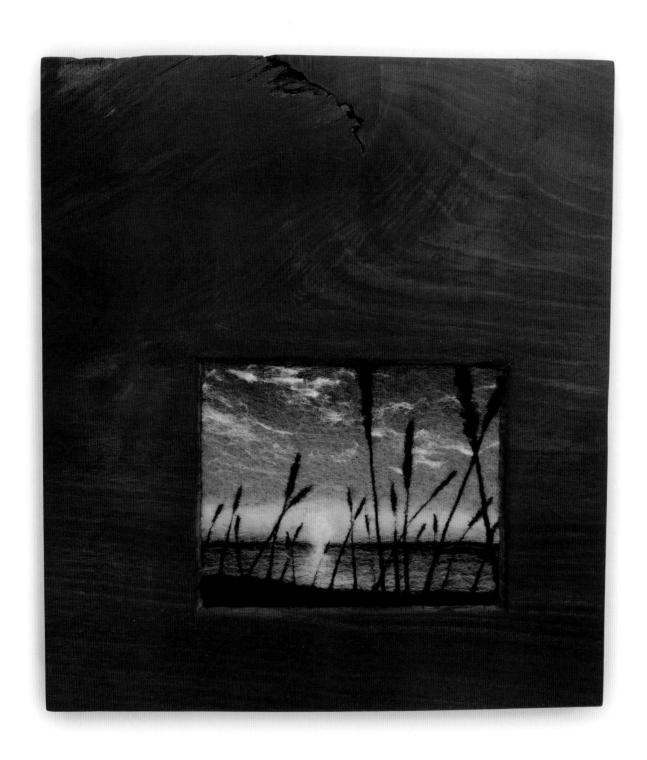

Sunset from the Dune, 2017, wool, walnut,
19" × 16" × 1"

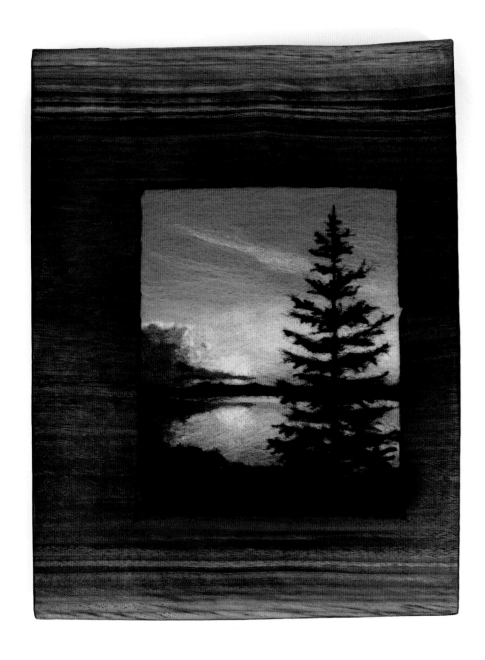

Spruce Lake at Sunset, 2018, wool, walnut,
18″ × 13.75″ × 2.25″

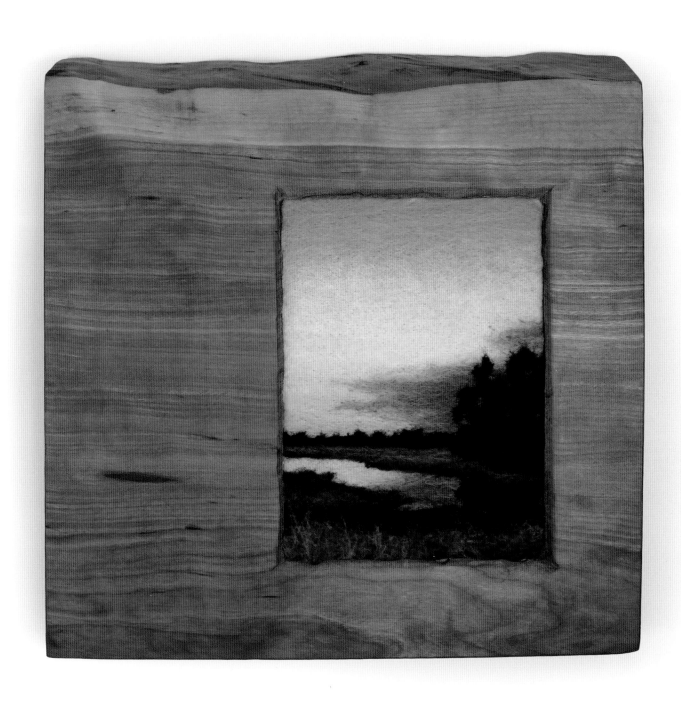

Dusk over the Creek, 2018, wool, cherry,
14.5" × 14" × 1.75"

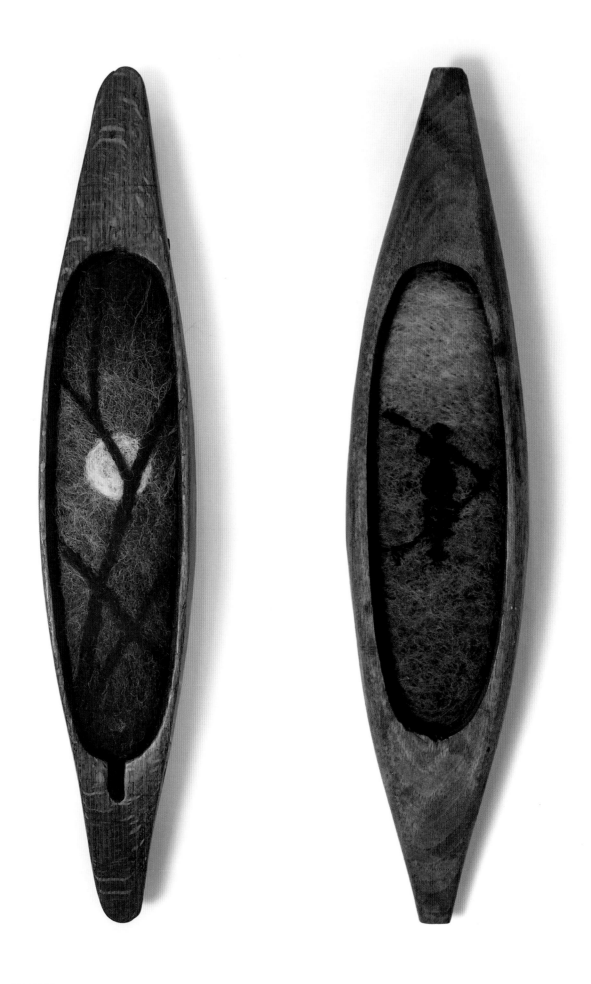

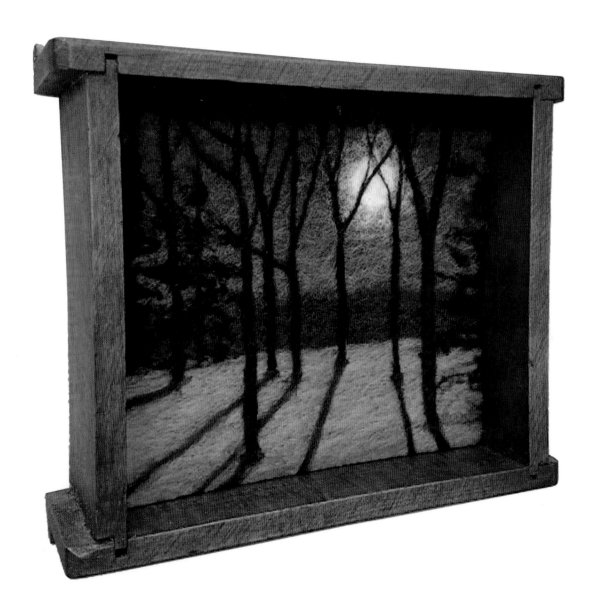

Opposite left: **Moon through Branches**, 2019, wool, antique shuttle,
10" × 2" × 1"

Opposite right: **Solitary Paddler**, 2019, wool, antique shuttle,
10.75" × 2.25" × 1.25"

Moonshadows in Cutter Box, 2018, wool, antique cutter,
8.5" × 8.5" × 2.5"

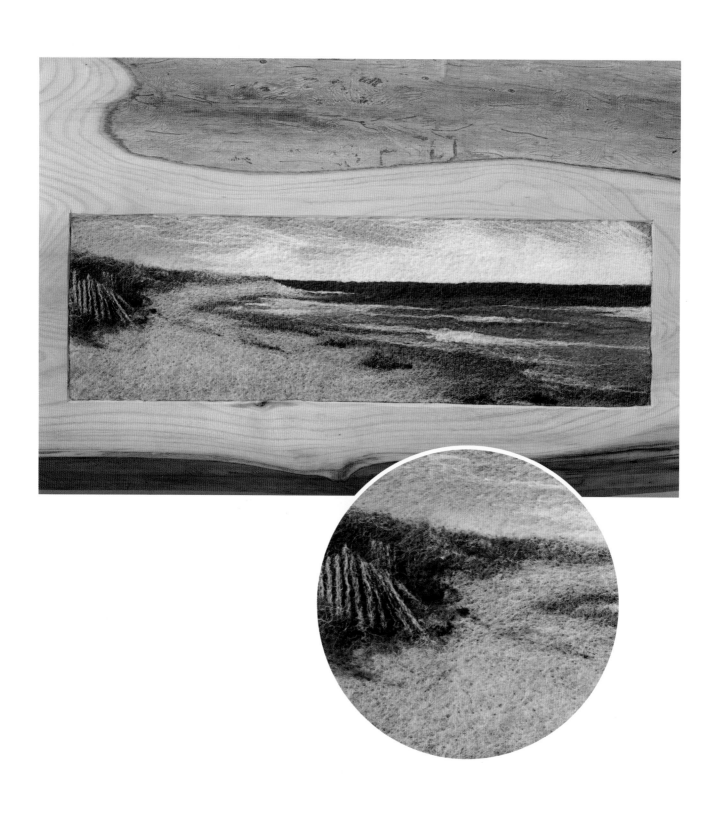

Seashore in Cottonwood, 2015, wool, cottonwood,
22" × 38" × 2.25"

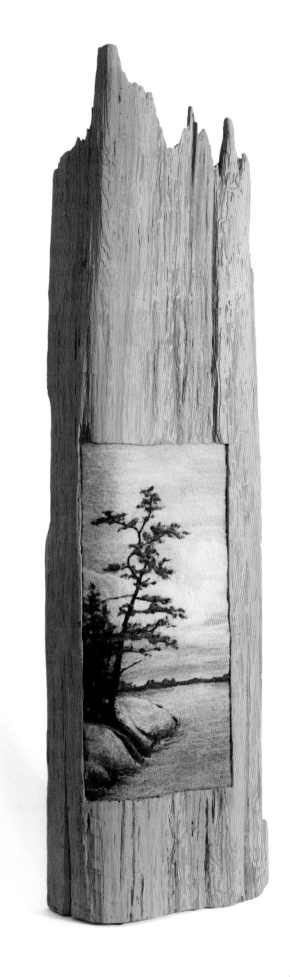

Northshore in Standing Driftwood, 2015,
wool, cypress trunk, 45" × 13" × 6"

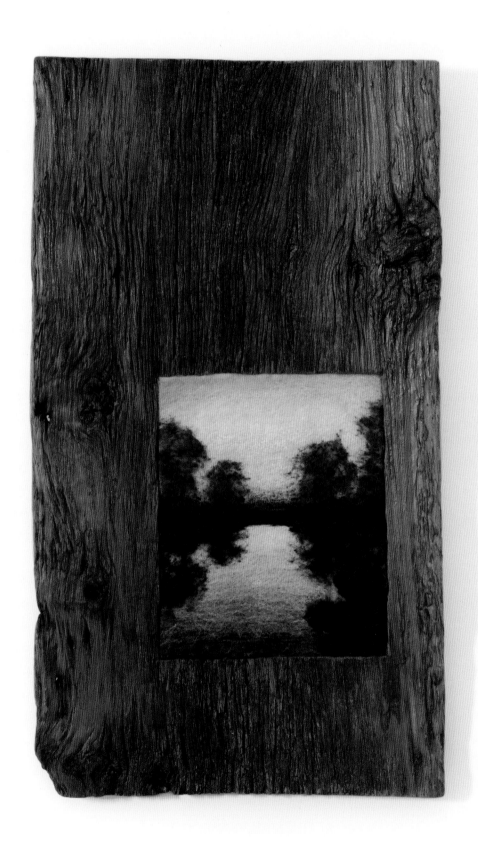

Sunset on the Pond, 2015, wool, oak barnwood,
29.5" × 17" × 1"

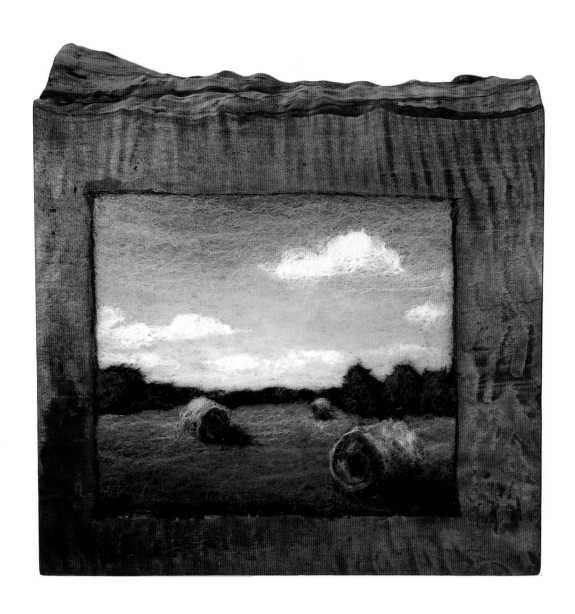

Haybales in Maple Block, 2014, wool, maple,
11" × 11" × 2"

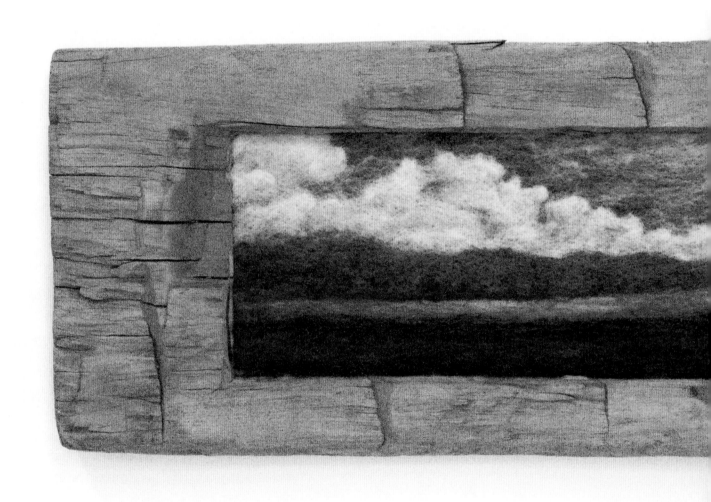

Barns in Hewn Timber, 2019, wool, barn timber,
6" × 21" × 1.5"

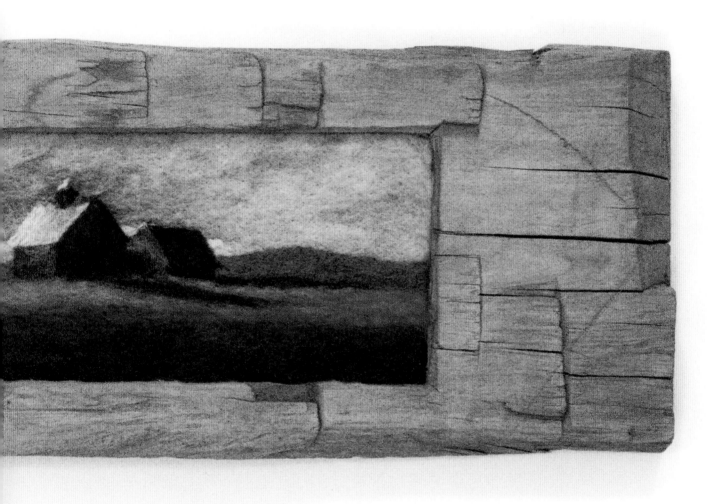

CONCLUSION

Many artists like to fall down the rabbit hole of new ideas as "studio hermits," content in our creative isolation, and kept company by the possibilities that can take shape in our own hands. Since I had an education in fiber arts before I first stumbled across needle felting, I knew I was seeing a new path in fibers, based on a largely unexplored tool. After a few false starts and frustrations, I began to get an inkling of uncharted territories (a thrilling prospect to me). I was eager to see what I could develop without being distracted or intimidated by the work of others, so for a while I kept my head down in the studio, embracing my hermit lifestyle as I experimented, content with simple discoveries but hungry for more. I was inspired by my lifelong awe of the natural landscape and applied lessons from art history as I learned what the materials wanted to do.

Once I decided to lift my head and looked around, I was amazed at what others had also developed with needle felting, each seemingly finding their own way to use the tools and materials with astonishing and diverse results. I was convinced by the curiosity of patrons at shows that my own way of working was unique, too, so I finally stepped outside my comfort zone and began to teach workshops. I have been so rewarded by the enthusiasm and energy of others. I love seeing people thrilled by the results of their own efforts, and each person I teach inspires me to be a better teacher. My own understanding of the work and techniques grows as I am asked to explain things that I hadn't even articulated to myself. So now, the evolution of these needle felted landscapes is almost a collaboration; I share what I know, and students share what they discover, and we all grow together.

I hope you can tap into the thrill of discovery and the satisfaction of your own accomplishments by trying your hand at the tutorials in this book. As my own creative path is still guided by happy accidents and things yet unimagined, know that the way from here to there is to keep playing, keep working, keep learning, and keep trying . . . and have fun along the way!

Looking, Watching, Wondering, 2018, wool, steel, antique wooden shuttles, spool and shoe forms, each shuttle approx. 3" × 12" × 1.5"

NEEDLE FELTING GLOSSARY

This section offers a lot of information, some of which goes beyond what the beginner may need. If you continue to pursue needle felting and explore the available resources, you will run into many of these terms. In my experience, the world of fiber is part art, part history, part science, and part farming, so this list gives you a little help to navigate between those worlds.

base felt: Foundation fabric pinned to foam work surface as a canvas for needle felting

batt-style fibers (batting, pre-felt): Sheets or wads of loosely entangled, kinky fibers resembling quilt batting. Good for building bulk. Brushed out from a carding machine after being cleaned and processed.

blending: Creating a mix of colors by intermingling fibers by hand or carding machine

carding (combing): Separating locks of fiber by using brush paddles or large cylinders covered with fine metal wires (like a dog brush), used to comb, separate, or blend cleaned and processed wool into an even web of parallel fibers

craft felt (base felt, acrylic felt, synthetic felt): A generic term for manufactured felt of either acrylic or polyester. Inexpensive and readily available, generally used in white to best highlight roving color

crimp (elasticity): Natural kinks, bends, or waves in individual fiber, formed permanently as fiber grows to create degrees of elasticity (stretch and rebound). Measured by crimps per inch.

dry blocking (flattening): Systematically reworking entire piece with felting needles to flatten and stabilize textile after removing needle felted work from foam work surface

dry felting (needle felting): Process of creating a textile or object with needles only

felt: Fabric created when loose wool fibers are interlocked and entangled to transform the fibers into a compacted, cohesive material

felting needle (punch needle): A long needle with very sharp tip and small, downward barbs notched into the sides, with a hook end used to anchor needles into holders. Originally created for industrial use. Various shapes and sizes available.

finger blending: Mixing wisps of different colors of roving by hand

fleece (raw fleece, greasy wool): Unwashed wool shorn from a sheep, scoured to remove lanolin, dirt, and vegetable matter with lock structure still intact. Fibers can then be teased open to be worked into tops, batts, or roving.

foam (work surface, sponge): A firm, dense upholstery- or packaging-grade open-cell foam, ideal work surface for needle felting

fulling: Finishing process for a firmer felt, where textile is agitated so that fibers continue to intertwine and shrink

lanolin (grease, oil): Natural oily or waxy fatty substance found in wool fleece, which is cleaned from fiber before felting or spinning. Extracted for balms and cosmetics.

locks: Well-defined clumps of fiber that hold together naturally in some fleece; must be teased to open fibers

merino: Breed of sheep producing fine fiber with a long staple

micron (diameter): Measurement of fiber thickness; a typical human hair is approximately 100 microns.

needle felting (flat felting, dry felting): Using one or more felting needles by hand, repeatedly jabbing the notched needle through loose fiber to entangle wool until it becomes a felt object or textile

needle holders (handle, tool): Variety of tool handles in wood, aluminum, and plastic that hold from one to twenty replaceable felting needles, anchored by the hook end of the needle

nep: A tangled knot of short, broken, or disarranged fibers

nesting: Taking a small pinch or wisp of roving-style fiber, pulling it apart lightly, and rubbing between three fingers to make a loose wad. Nested fiber can be anchored with a few pokes and then "swirled" around the needle if concentrated fiber is desired. Turns long-stapled fiber into a more batt-like application for increased elasticity and malleability to shape object (clouds, trees, etc.).

pre-felt batts: Loosely prepared fabric made from layers of roving run in different directions, only slightly matted so as not to be fully felted. Can be finished with different wet or dry techniques.

roving tops: Longer fibers that have been loosely drawn into a continuous thin rope, to be used for spinning or felting

scale: Microscopic, rough, shingle-like ridges that cover the surface of a wool fiber, which can interlock with each other to create felt

staple (fiber): Natural length of an individual fiber. Varies by sheep's breed, age, health, and environment, and the part of the sheep.

Superwash™ wool: Commercially produced, machine-washable, nonshrinking wool fiber typically used for clothing. Does not felt well, since scales have either been stripped with chlorine or coated with polymer resin (or both) to prevent interlocking.

swirling: Circling your needle several times through loose fiber that has been lightly anchored. This gathers the fine and unwieldy fibers before felting it down in a defined area.

tops (wool tops, combed tops, roving): Longest wool fibers, which have been washed, combed, and sorted until fibers run in the same direction in long, loose ropes.

wet felting: Textile or object created by felting fibers with water, heat, and pressure

wool: Soft, wavy fibers (entire fleece or single fiber) obtained from sheep and other hairy animals, consisting mainly of protein or keratin and covered with minute scales

USEFUL RESOURCES

Hart, Peggy. *Wool: Unraveling an American Story of Artisans and Innovation*. Atglen, PA: Schiffer, 2017.

Lane, Ruth. *The Complete Photo Guide to Felting*. Minneapolis: Creative Publishing International, 2012.

Mackay, Moy. *Art in Felt and Stitch*. Kent, UK: Search Press, 2012.

Robson, Deborah, and Carol Ekarius. *The Field Guide to Fleece*. North Adams, MA: Storey, 2012.

Smith, Sheila. *Felt Fabric Designs*. London: Batsford, 2013.

Talpai, Ayala. *The Felting Needle from Factory to Fantasy*. 2nd ed. Salem, OR: Your Town, 2002.

Zwimpfer, Moritz. *Color, Light, Sight, Sense*. West Chester, PA: Schiffer, 1988.